THE INKING WOMAN

*250 years of Women
Cartoon and Comic Artists
in Britain*

Edited by
Nicola Streeten & Cath Tate

First published in 2018 by
Myriad Editions
www.myriadeditions.com

Myriad Editions
An imprint of New Internationalist Publications
The Old Music Hall, 106–108 Cowley Rd, Oxford OX4 1JE

Second printing
3 5 7 9 10 8 6 4 2

A CIP catalogue record for this book
is available from the British Library.

ISBN: 978-0-9955900-8-3

Designed by Marcia Mihotich

Printed in Poland on paper sourced from sustainable forests

*To women cartoonists
and comics artists past and present*

Contents

Preface

'Why are there no women cartoonists?' This is a question I have been asked on more than one occasion at the Cartoon Museum in London. Well, actually, there are – and lots of them – as this book proves.

In 2017, the Cartoon Museum was delighted to showcase the work of 100 British women cartoonists and comic artists in our exhibition 'The Inking Woman'. The show was an opportunity for women artists of different ages, backgrounds and opinions from around the world to come together – some of whom used cartoons and comics to comment on the world of the 1970s and 1980s but now express themselves in other ways. Also present were women artists whose intense experiences included loss of close family members, life-threatening illness and sexual abuse, as well as personal and political encounters that were shaped into compelling narratives to be shared with the wider world. And, of course, there were also the joke cartoonists, who use humour, often surreal, to make social or personal observations through their artwork.

This book, and the exhibition which inspired it, reveals a wealth of women's wit and insight spanning some 250 years. In it, you will find a wide-ranging selection of prints from the eighteenth century, caricatures, jokes, editorial and strip cartoons from magazines and newspapers, postcards, comics, zines, graphic novels and digital comics. The exhibition – the largest of its kind to date – and the book demonstrate that women have always had both a wicked sense of humour and a perceptive view of the world. Some of the cartoons will be familiar, but there are also forgotten gems from the past.

The Inking Woman is a celebration of the vibrancy and variety of women's cartoon and comic expression in the UK. It reveals some of the challenges women artists have faced over the past 250 years. Through their own hard work, by developing support networks and by confronting sexist attitudes within the art world and the wider society, women have put themselves on the cartoon and comic makers' map – producing striking and important work which will continue to resonate for years to come.

Anita O'Brien
Curator
Cartoon Museum, London

Introduction
Cath Tate

I first had the idea of an exhibition and a book of women cartoonists working in Britain back in 1993. At the time, I was publishing and selling postcards and calendars of gag cartoons by women and had become aware of how much good work was being produced. Most of the cartoons I was publishing had come out of the ideas of the women's movement of the late 1970s and 1980s in Britain. Much of this work was slipping under the mainstream radar and I felt that an exhibition and a book would give the work a higher profile. Back then, my fantasy project came to nothing because there was no money for it. Humour is a very personal thing and what you think of as funny is often determined by your life experiences. The (then mostly) male editors of publications didn't always share women's sense of humour.

Fast forward to 2016 and Cath Tate Cards was in a position to sponsor an exhibition and a book of women's cartoon work. In some ways, the delay was good; we were now able to include all the new and inspiring work that had been produced in the intervening years.

We felt it was also important to look back as far as the eighteenth century and include women cartoonists who have been largely forgotten because so little about them has been written. Many were quite well-known in their day, for example, Fish, Anton and Belsky, though few people realised that they were women.

Although the number of artists included here exceeds those shown at The Cartoon Museum, the captions and biographies collected and written by Anita O'Brien for the exhibition provided an invaluable archive and basis for gathering information about the artists and their works for this book.

We circulated questionnaires to the cartoonists asking them to respond with stories of the provenance of their works and to reflect on their experience of cartooning. The response was overwhelming in its generosity and the tales they sent provided us with fascinating insights into the working practices of women cartoonists in Britain. The wealth of material warrants another book and we have teased out elements here to add a personal context to accompany the images. Time and again they came back with stories from their careers of being asked: 'Are there any women cartoonists?' or 'Do women have a sense of humour?'. We hope this book puts paid to those myths and means that their work will not be buried and forgotten.

In this survey, we have done our best to present the most comprehensive overview of the topic but the more we researched, the more women cartoonists we found and we realised that there might be vital women who have been overlooked. We hope that above all, this book serves as an encouragement for a new generation of women to pick up a pen and show us the world through their eyes.

I personally would like to say a big thank you to Anita O'Brien, Kate Charlesworth, Corinne Pearlman and Nicola Streeten for their support and expertise in the preparation of the exhibition and the book. You have all been a joy to work with.

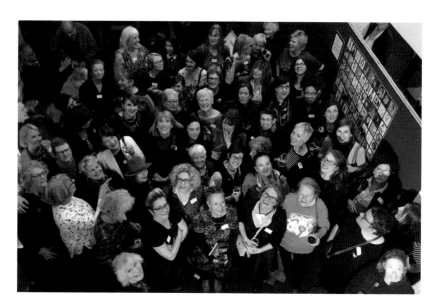

RIGHT © Rosie Tate, 2017. Cartoonists who attended the opening of 'The Inking Woman' exhibition at the Cartoon Museum, London on 26th April 2017.

Introduction
Nicola Streeten

The opening night of 'The Inking Woman' exhibition was a glorious gathering of women cartoonists of all ages. It was a joy for us all to be brought together and celebrated. It is from the 1970s that the story of British women cartooning becomes a living history and most cartoonists from those days are with us and able to share their stories, which they have generously done for this publication. Cath Tate and I both have roles in this history. For my own part, cartoons by Jacky Fleming, Annie Lawson, Ros Asquith and other women provided the sight track of my teenage years. Their work influenced me in terms of style and, just as importantly, my feminist education. The cartoons published by Cath Tate were a major influence on my early illustration career in the 1990s. It is therefore an absolute delight and honour for me to have been able to work with Cath on this project as well as to have had contact with so many inspiring women creators. Currently, my drawing practice and role as co-founder of Laydeez do Comics has made me aware of an increasingly buoyant community of women practitioners, and it is my own and Cath's personal positions that have shaped our motivation in reflecting this activity in documented form.

Before we present this wonderful array of images, it is pertinent to clarify the difference between cartoons and comics, and to outline the criteria for the selection of works. These decisions reflect the thoughts and discussions behind 'The Inking Woman' exhibition. Although our intention is to address a gap in the history of British comics, many of the works we include are cartoons, that is, one panel gags. Within comic scholarship, opinion is divided as to whether cartoons can be described as comics. One school of thought insists they must be viewed differently, because cartoons do not contain sequentiality, which is a critical ingredient in defining the comics form. Our view is that cartoon gags should be included under the umbrella of comics because, like comics, they blend image and text. In our choice of cartoons, our interest has reached beyond the typical party-political newspaper cartoon to include works that reflect the human experience.

Another important preference in our selection criteria has been for works by auteurs, where one author creates the idea, image and text. Their practice is in contrast to the teams of writers, drawers, inkers and letterers working for publishers such as DC Comics and Marvel to produce what we may refer to as 'mainstream' comics. Historically, superhero comics and children's comics which dominate this very popular section of the industry have had a predominantly male appeal and male workforce.

Finally, we have worked with historical cartoons that reflect a Britain very different from the one we know today. Cartooning women have emerged from a position of social privilege, perhaps most evident in the works from women's suffrage. This characteristic is indicative of a wider structural system. What we hope is that the more recent cartooning reflects a changing society that questions not only what it means to be a cartoonist in Britain, but also the breadth of subject-matter the cartoon form can address and the variety of ways in which this can be done.

I reiterate Cath's hope that this book will be the first of many documentating both the historical and current activity of women cartoonists in Britain. On that note, we invite you to enjoy the following glimpse of a generally overlooked abundance of visual enterprise.

Mary Darly:

Visual satire and caricature in eighteenth-century Britain

Sheila O'Connell

Visual satire in eighteenth-century Britain was an elitist matter. Cartoons were sold as prints and published on separate sheets that were relatively expensive, with the modern newspaper cartoons appearing later, in the nineteenth century. It was largely a masculine world in terms of the production and readership. However, women did have a role in production and were certainly represented visually. As subjects of the mainstream satire, celebrated women often featured in these prints. For example, Queen Charlotte was satirised for her love of jewellery; Maria Fitzherbert for her secret marriage to the Prince of Wales; the Duchess of Devonshire for getting involved in politics; as well as Elizabeth Farren, Dorothy Jordan and many other actresses for their affairs with prominent men.

One contribution from women was in the support of the industry through patronage. Among the subscribers to Hogarth's Election series were the Countess of Yarmouth, the Duchess of Portland and a well-known lesbian couple, Elizabeth Cavendish and Lady Dysart.[1] Women were directly involved in the industry through running print-publishing businesses. These included Elizabeth Bakewell, Mary Cooper, Elizabeth Dachery, Anne Dodd, Elizabeth Walker and the brilliant Hannah Humphrey, who published James Gillray's great prints at the end of the century. Drawing was part of the education of 'well-bred' women and those with a sense of humour inevitably turned to satire. As early as 1734, Dorothy Boyle, Lady Burlington, designed a print making fun of fashionable opera. One of the most well-known women who combined their drawing skills with publishing was Mary Darly.

Print publishing, like most businesses at the time, was a family affair. Daughters, sisters and wives often took care of the accounts, served in the shops and carried out a range of behind-the-scenes activities. Their names usually came to light only when they became widows and took on the firm. Mary Darly was different. In 1759, she married Matthias Darly – an established printmaker and publisher with a shop

in the Strand, near Charing Cross. Mary soon took an important role in the business and opened her own shop in Ryder's Court, just around the corner from Leicester House – the home of Augusta, Princess of Wales and the focus of much political machination.

Augusta became the subject of many prints when her son became George III in 1760. It was suggested (with no obvious proof) that she was the lover of George's deeply unpopular prime minister, Lord Bute. Mary Darly's satires on the subject were as lewd as those by her male colleagues. Much was made of Augusta's pleasure in the handsome minister's 'mighty staff' or his 'broomstick', and the Princess was compared with other women accused of shameless sexual behaviour such as Catherine the Great or Mary, Queen of Scots. The Darlys and other satirists received vicious attacks, and turned their business attention from what

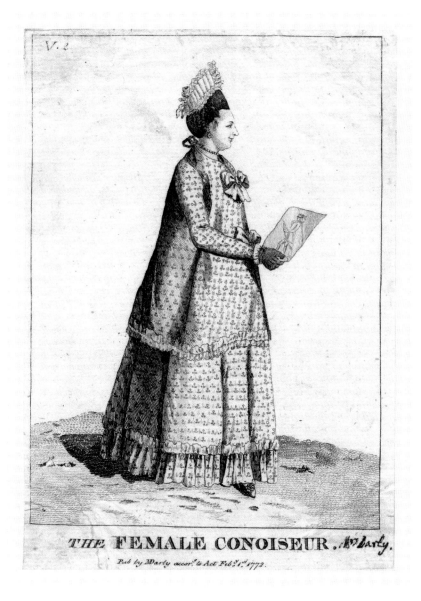

THE **FEMALE** CONOISEUR. *Mʳ Darly.*

Pub by M Darly accorᵗ to Act Febʸ 1ˢᵗ 1772.

ABOVE © Mary Darly, 'The Female Conoiseur', 1772. Published by Mary Darly.

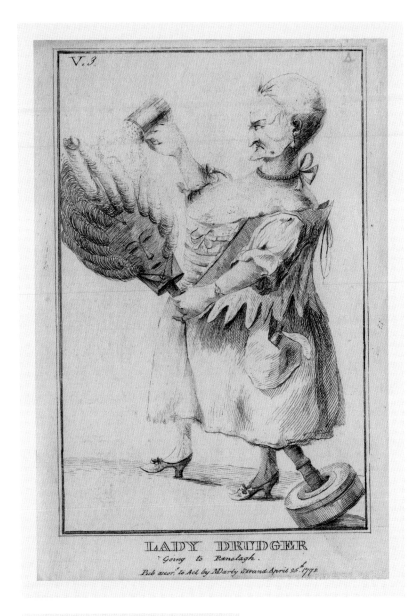

LADY DRUDGER
'Going to Ranelagh.
Pub accor.t to Act by MDarly Strand April 25. 1772

they later referred to as 'low or political subjects' to satirising social mores.

Mary Darly was the first to recognise the commercial potential of the fashion for caricature, the gross exaggeration of facial features that was brought from Italy by wealthy young men returning from grand tours. She encouraged them to create their own caricatures of friends and rivals. In September 1762 she advertised that 'Gentlemen and Ladies may have any Sketch or Fancy of their own, engraved, etched &c. with the utmost Despatch and Secrecy' and the following month she published *A Book of Caricaturas on Sixty Copper Plates, with ye Principles of Designing in that Droll & pleasing manner with examples of caricatures to follow* 'till drawing in this manner becomes familiar & easy & is attended with pleasure.' In 1771 the Darlys issued the first of their immensely successful series of *Caricatures by Several Ladies and Gentlemen.*

The Darlys came up with a best-selling formula for less controversial prints that mocked 'the follies of the age'. They began to make fun of 'Macaronies', foppish young men who sported effeminate fashions and extravagant hairstyles, and soon almost anyone in the public gaze was described as a Macaroni of one kind or another. The Darly shop in the Strand became known as the Macaroni Printshop. Over the next few years, hundreds of Macaroni prints appeared and the figures of (usually gentle) fun were often identifiable. For example, 'The Fly Catching Macaroni' is the eminent botanist Sir Joseph Banks; 'The Antique Architect' is Robert Adam; 'The Female Conoiseur' is thought to be a portrait of Mary Darly herself.

ABOVE © Mary Darly, 'Lady Drudger', 1772. From *Caricatures, Macaronies & Characters*, published by Mary Darly. An old woman prepares an elaborate wig to cover her thinning hair.

BELOW © Mary Darly, 'The VauxHall Demi-Rep', 1772. From *Caricatures, Macaronies & Characters*, published by Mary Darly. A woman of 'easy virtue' who frequented Vauxhall Gardens.

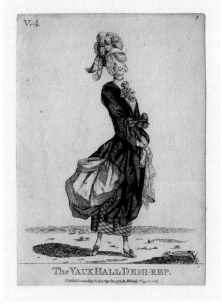

The VAUXHALL DEMI-REP.

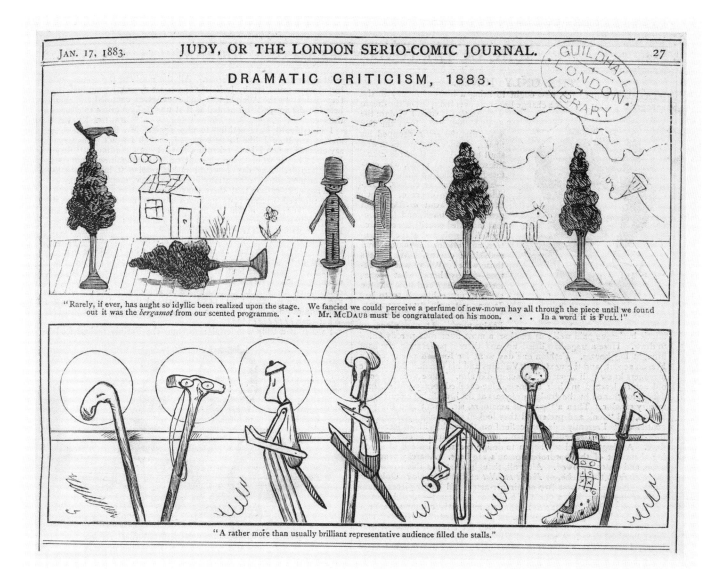

DRAMATIC CRITICISM, 1883.

"Rarely, if ever, has aught so idyllic been realized upon the stage. We fancied we could perceive a perfume of new-mown hay all through the piece until we found out it was the *bergamot* from our scented programme. . . . Mr. McDAUB must be congratulated on his moon. . . . In a word it is FULL!"

"A rather more than usually brilliant representative audience filled the stalls."

ABOVE © Marie Duval, 'Dramatic Criticism, 1883'. *Judy, or the London Serio-comic Journal*, Volume 32, page 27, 17 January 1883.

Marie Duval:
A Victorian cartoonist
Simon Grennan

The work of Marie Duval confounds one of our most commonplace ideas of the Victorian era: that women were not supposed to create or even to participate in public life, and most certainly were not meant to be either comic or professional. Duval's comic strips did not make her a pioneer in terms of what we have come to call 'comics', but present a vernacular comedy that frequently undercuts and supersedes the work of her male contemporaries.

Marie Duval was a pseudonym of Isabella Emily Louisa Tessier (1847–1890), a London-born actress, cartoonist and illustrator who also used the names 'Noir' and 'SA The Princess Hesse Schwartzbourg'. Her work appeared in a variety of the cheap, British penny papers and comics of the 1860s, 1870s and 1880s.

The final three decades of the nineteenth century were, particularly for town- and city-dwellers, a first age of leisure. Working people had more money and more spare time than ever before. It was the era of bank holidays, hobbies, trips to the seaside, music halls, and organised sport. Duval contributed to the creation of a new urban media environment, in which professional definitions were being created for the first time, for both women and men, and in which synergies between different types of media culture emerged.

Even in this environment of shifting boundaries and new opportunities, Duval was an unusual figure. Although women contemporaries also worked in visual journalism, they had usually taken advantage of some quirk in their personal circumstances that gave them access to visual-arts training. Duval, however, made her lack of training an important aspect of her comedic drawing style – her visual brand. For conventional skills, she substituted her experience of performance, circus, pantomime and theatre spectacle, developing a style that was radically at odds with her contemporaries. Duval was able to position herself perfectly so as to pioneer a new drawing style and new types of visual storytelling, and to make comedy from the juxtaposition of ideas of public culture – its aspirants and practitioners – with the lived realities and pleasures of urban life.

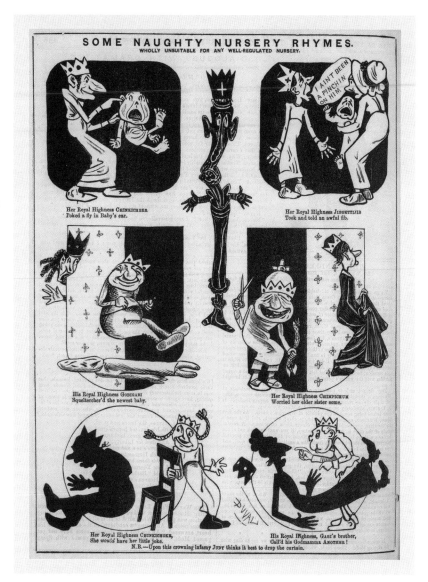

In one of her most deft and complex drawings, Duval manages to make use of the pretensions of theatre production to mock the audience, while using the pretensions of the audience to mock the players. Her readers, meanwhile, see audience members, players and stage as little more than wooden dolls, childish daubs and walking sticks.

Duval often parodied the modern incongruities of the fashion for medievalism, pervasive throughout the nineteenth century. From Walter Scott to the Aesthetic Movement, this fashion was relentlessly serious and often aspirational – a fact that Duval exploited ruthlessly to comic effect.

ABOVE © Marie Duval, 'Some naughty nursery rhymes. Wholly unsuitable for any well-regulated nursery'. *Judy, the London Serio-comic Journal*, Volume 18, page 234, 22 March 1876.

Women's suffrage in cartoons

Elizabeth Crawford

For 40 years after the launch of the 'votes for women' campaign in 1866, its activists were the cartooned rather than the cartoonists.

The transgressive idea of women claiming 'rights' had an obvious appeal to nineteenth-century male cartoonists. The women who dared to break with the convention that barred them from the public sphere were lampooned in mainstream newspapers and journals. The satirical magazine *Punch* (1841–2002), in particular, poked fun at the uppity 'women righters' and the men who were prepared to take up their cause in parliament.[1] No woman cartooned for such papers, either to mock or sympathise with her suffrage sisters, and the women's campaign had no paper of its own until 1870 when Lydia Becker, who led the campaign in Manchester, launched *The Women's Suffrage Journal*. Dense with print, *The Women's Suffrage Journal* had no illustrations and ceased with Miss Becker's death in 1890. It was not until the campaign took on a fresh lease of life at the beginning of the twentieth century that women artists were at last able to cartoon for their cause. The first paper to offer such an opportunity was *Women's Franchise*, in which a cartoon appeared for the first time in the 26 December 1907 issue.

In January 1907, a group of professional women artists had founded the Artists' Suffrage League (ASL). The motivation was to produce campaign material for the first large-scale women's suffrage demonstration planned by the National Union of Women's Suffrage Societies (NUWSS). Referred to as 'the Mud March' it took place the following month in London and gathered around 3,000 women. The NUWSS was an umbrella group for numerous local suffrage societies. It favoured constitutional tactics, unlike the recently-founded Women's Social and Political Union (WSPU) which was prepared to take more direct action. The ASL made its mission explicit: 'To further the cause of Women's Enfranchisement by the work and professional help of artists… by bringing in an attractive manner before the public eye the long-continued demand for the vote'.[2] Disapproving of the militancy of the WSPU, the ASL chose to only support the constitutional campaign.

BELOW © Dora Meeson Coates, 'Polling Booth – Companions in Disgrace', 1907. First published in *Women's Franchise*, 26 December 1907. This cartoon was subsequently issued as a postcard by the Artists' Suffrage League. Author's collection.

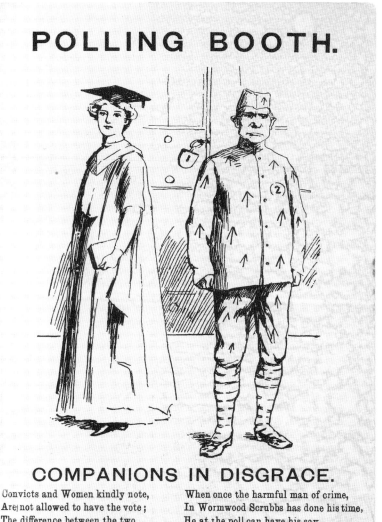

POLLING BOOTH.

COMPANIONS IN DISGRACE.

Convicts and Women kindly note,
Are not allowed to have the vote;
The difference between the two
I will now indicate to you.

When once the harmful man of crime,
In Wormwood Scrubbs has done his time,
He at the poll can have his say,
The harmless woman *never* may.

C. H.

Printed and Published by the Artists' Suffrage League.
259 King's Road, Chelsea.

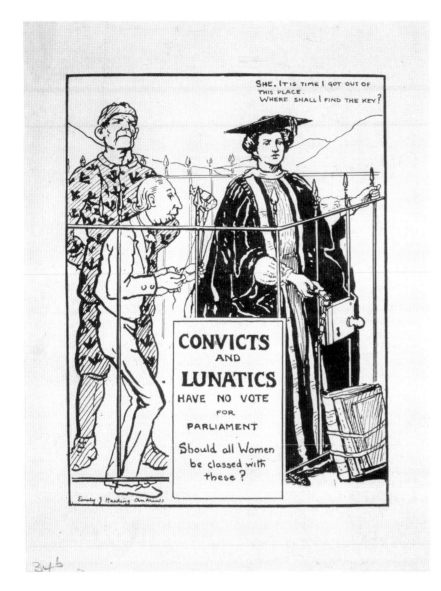

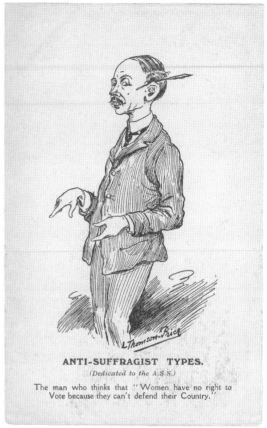

ANTI-SUFFRAGIST TYPES.
(Dedicated to the A.S.S.)

The man who thinks that "Women have no right to Vote because they can't defend their Country."

LEFT © Emily Harding Andrews, 'Convicts, Lunatics and Women! Have No Vote in Parliament', c. 1908. Held in the Mary Lowndes Album. From LSE Library Collection: 2ASL/11.

RIGHT © Louisa Thomson-Price, 'Anti-Suffragist Types', c. 1910. One of a series of cartoons issued as postcards by the Women's Freedom League. Author's collection.

The society was London-based: its founder and chair, Mary Lowndes (1856–1929), like most of the ASL committee, lived in Chelsea. She differed from other members in that, after completing her fine-art studies at the Slade School of Art, she had received further training in stained glass and ran a workshop, Lowndes and Drury, Stained Glass Workers. These additional craft skills would have been advantageous in creating designs in a variety of media.[3]

The majority of the women of the ASL had been born in the 1850s and 1860s and had, with some difficulty, acquired fine-art training and then found work as exhibiting artists or book illustrators. It was not an easy path to follow for, as one of their cohort put it, 'student life was hedged about with limitations set by men, handicapping her ultimate career...'. This same artist concluded that 'the difficulties placed in women's professional paths make them feminists'.[4] Known to each other through their

time spent at art school or through their subsequent experience of exhibiting, the women of the ASL were ready to make visible their support for the suffrage movement in whatever media best suited the occasion. After producing banners for the NUWSS march in February, the ASL turned its attention to the poster and in June 1907, in association with the NUWSS, launched a 'Poster and Picture Post Card' competition. It was specifically noted that the poster 'in favour of Women's Suffrage' was to be 'for use at Parliamentary Elections'.[5] In January 1908, the judges were able to agree on a winner: Dora Meeson Coates.[6] Her winning design 'Political Help' featured a character that was to be a great favourite with suffrage artists, 'Mrs John Bull'.

The artist who shared second prize in the NUWSS/ASL competition was Emily Harding Andrews (1851–1940), an established book illustrator. She produced several posters and postcards for the ASL.

One of her best-known designs, 'Convicts, Lunatics and Women! Have No Vote for Parliament' was published by the ASL around 1908 and proved so popular that it was reprinted, with slight alterations, in 1910.

A glamorously dignified woman graduate is contrasted, to her great advantage, with cartoonish 'convict' and 'lunatic' men, representing the other groups barred from voting. This theme, previously highlighted in DM's cartoon in *Women's Franchise*, was one that clearly had strong resonance with the well-educated, middle-class women conducting the constitutional suffrage campaign and was taken up again a few years later in a Suffrage Atelier design. Such representations bore no similarity to those on commercial postcards featuring cartoons drawn by men conveying the mainstream anti-suffrage message. Their women were not dignified, but invariably shown as big-footed, umbrella-waving, brick-throwing harridans. The suffrage artists retaliated by producing similarly cartoonish images of men.

A second artists' suffrage society, the Suffrage Atelier (SA), was formed in 1909 and was prepared to work with all suffrage societies, militant as well as constitutional. It described itself as 'An Arts and Crafts Society Working for the Enfranchisement of Women', suggesting it intended to distinguish itself from the ASL, whose members were fine-art trained. In fact, of the two founders of the SA, one, Ethel Willis (1870–1954), appears to have had no professional training, whereas the other, Hope Joseph (1878–1953), had attended art school in Bristol, followed by time at the Stanhope Forbes school at Newlyn and then at an atelier in Paris. Unlike the ASL, the SA paid artists for their designs and also held classes – giving practical instruction to its members in methods of process block reproduction and hand-coloured printing to enable them to create the bold images its founders favoured. One of the meetings of this 'Cartoon Club' was held in the north London studio of Catherine Courtauld (1878–1952), an artist who produced many designs for the SA, one of which, 'A Living Wage', exemplified the SA's concern for social issues. Although the wealthy Courtaulds were a family that had tempered financial success with care for its workers, this poster – which shows a woman chainmaker encountering 'Starvation' – acknowledges that this was by no means the rule in Edwardian Britain.[7] Most SA productions are anonymous and Catherine Courtauld was unusual in putting her signature, or at least her initials, to her work.

The lot of poor working-class women was one that both suffrage artists' societies were concerned to

highlight. For although the intention of the women's suffrage campaigners was that only women who met the relevant property qualifications would be granted the vote, their idea was that, once the vote had been won, newly-enfranchised women would be able to use it to improve the lot of their poorer sisters.

An early ASL postcard, the work of Mary Lowndes, highlighted the prejudice against women which threatened to keep them voteless (without an umbrella) and also questioned their right to work outside the home. This postcard first appeared as a cartoon in *Women's Franchise*, in January 1908. The ways in which women of all classes were at a disadvantage in a society where the laws were made by men was a subject that appealed to a number of suffrage cartoonists. Several other themes were highlighted by both artists' suffrage societies. Lending itself particularly to visual representation was the fact that the door of Parliament was metaphorically barred to women. The SA was founded at a time when the WSPU campaign was becoming increasingly militant and, unlike, the ASL, over the next five years railed against the treatment that suffragettes suffered in prison. Some of its starkest images are on this theme.

When the cartoon survives only as a postcard, and the message is taken out of context, it can sometimes be a little difficult to decipher. However, the vast majority of this type of cartoon were published in the suffrage press, where the surrounding editorial content allows us easily to unpick the meaning and recognize that the suffrage cartoonists were adept at conveying complicated political concepts to their readers in simple and striking images.

The WSPU launched its newspaper, *Votes for Women*, in 1907; and in 1909, it was followed by the Women's Freedom League's *The Vote* and the NUWSS's *Common Cause*. These papers were sold at suffrage meetings and on the street by women prepared to brave the mocking of bystanders. However, as the marketing of the suffrage campaign became increasingly sophisticated, the main societies opened shops from which the public could buy a wide range of branded goods, including their postcards, posters and papers. All of these weekly papers included cartoons commenting on the latest news as it affected the suffrage campaign.

The Pankhursts launched a new WSPU paper, *The Suffragette*, which usually carried a cartoon on its front page. It has, however, proved impossible to identify most of *The Suffragette*'s artists. From the meagre records that survive it is possible to deduce a little of

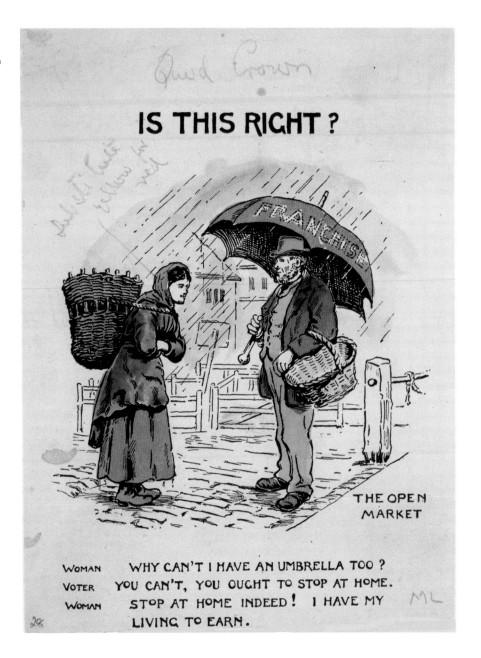

the realities of the ASL and the SA collectives.[8] The SA members met regularly to take part in workshop sessions, such as the Cartoon Club, and to be entertained at monthly 'At Homes', at which a feminist lecture might be given or non-suffrage work exhibited. The only recorded ASL gatherings were formal meetings, such as the Annual General Meeting addressed by a speaker. These probably took place in the informal surroundings of an artist's studio; for instance, in 1909 Emily Ford, renowned for her 'Coffee Smokes', played hostess.[9]

Most of the women who produced the suffrage cartoons were trying to maintain professional careers at the same time, and were unable or unwilling to follow the example of Marie Brackenbury (1866–1945) who contributed a witty cartoon to the 16 January 1908 issue of *Women's Franchise*, 'History Up to Date and More so... by A Pavement Artist', and a month later, on 11 February 1908, was sent to Holloway.[10] Instead, recognizing that wry humour was a useful weapon in their fight for the vote, the cartoonists continued producing work until the outbreak of the First World War in 1914 brought this stage of the suffrage campaign to an end. There is little evidence that any of them cartooned again, which suggests that it was only the intensity of their desire for equal citizenship that led them down this novel path.

The 'Golden Age of the Postcard'

Cath Tate

The first third of the twentieth century is known as the 'Golden Age of the Postcard', when millions were sent every year by people from all walks of life. In 1894, a cheaper postage rate of half a penny was introduced for postcards. These early postcards had the name and address on one side and the written message on the other. In 1902, Post Office regulations changed to allow the message and address to be on one side and a picture on the other. At a time when few people had telephones and there were up to five postal deliveries a day, it was possible to send a postcard at lunchtime to say what time you would be home for tea. As we have seen, this medium had been used by women's suffrage campaigners to publicise their viewpoint to a wide audience. The cartoonists shown in the following pages were among those producing work for the commercial end of this enormous market.

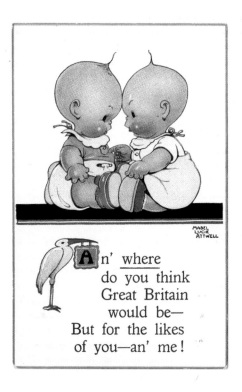

ABOVE © Mabel Lucie Attwell, 'Going through life with a smile, a song an' helping one's fellow man along!', c. 1930s. Valentine of Dundee postcard design. Watercolour with body colour. Chris Beetles Gallery, London.

LEFT © Mabel Lucie Attwell, 'An' where do you think Great Britain would be – But for the likes of you an' me!', c. 1920s. The Cartoon Museum, London. Roger Mayhew.

Mabel Lucie Attwell
(1879–1964)

Mabel Lucie Attwell was a very popular illustrator in the first half of the twentieth century. She became the family breadwinner after her husband was badly wounded in the First World War. As well as illustrating children's books, in 1914 she began producing postcard designs for Valentines of Dundee. Her initial career was founded on illustration for *Tatler, The Bystander, Little Folks,* the *Illustrated London News* and other magazines. From 1910, she illustrated children's classics such as *Mother Goose, The Water Babies* and *Peter Pan.* From 1914 onwards she developed her trademark style of sentimentalised rotund, cuddly infants which appeared on a wide range of products such as postcards, calendars, crockery, dolls, nursery equipment and pictures. Attwell also produced comic strips and worked in advertising. *Lucie Attwell's Annual* was published from 1922 to 1974, reissuing images after her death.

Hilda Cowham
(1873–1964)

Hilda Cowham was renowned for creating the 'Cowham Kids' – cute kids with skinny, elongated, black-stockinged legs. Her work was published in *The Sketch*, *Tatler*, *Ladies Realm* and other magazines. She also illustrated children's books such as *Fiddlesticks* and *Peter Pickle and his dog Fido* and many others. Between 1924 and 1935 she, like Mabel Lucie Attwell, was employed by Shelley Potteries to provide illustrations for baby plates and nurseryware. She was one of the first women illustrators published in *Punch*.

Tommy : Been to Heaven lately, father?
Father : No, my boy ; why?
Tommy (looking at skeleton) : Then where did you get him?

ABOVE © Hilda Cowham, 'The Humour of Life', *Tatler*, 1904.

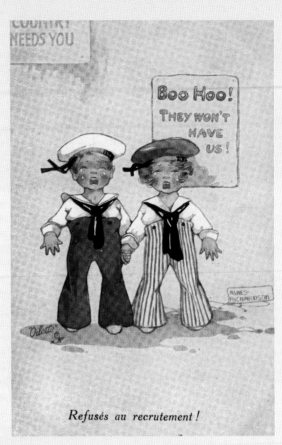

Refusés au recrutement !

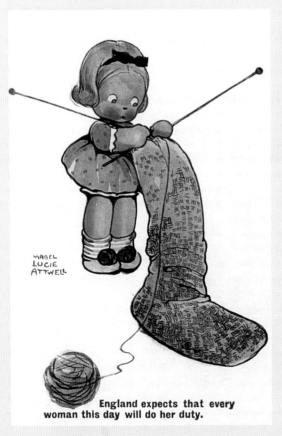

England expects that every woman this day will do her duty.

LEFT © Mabel Lucie Attwell Ltd/ Mary Evans Picture Library. Mabel Lucie Attwell, 'England expects that every woman this day will do her duty', c.1915. Carlton Publishing Company, Series No. 740. Illustration produced for a comic postcard during the First World War, reflecting the nation's mania for knitting 'comforts' for troops at the front. In this case, a small girl produces an enormous single khaki woollen sock.

ABOVE RIGHT © Agnes Richardson, 'Boo Hoo! They won't have us', c.1916. Inter-Art Co., London. Roger Mayhew.

Agnes Richardson
(1885–1951)

Agnes Richardson trained at Lambeth School of Art. She worked in a printer's studio which helped launch her 40-year-strong career. She designed posters for London Underground and illustrated children's books throughout the 1920s and 1930s. Her cards were published by Inter-art, Mack, Photochrom & Tuck.

Flora White
(1878–1953)

Phyllis M. Purser
(1893–1989)

Flora White trained at the Brighton School of Art and focused on a commercial art career from 1915. She drew images for postcards published by several companies and she also illustrated children's books.

Phyllis M. Purser produced gently humorous postcard designs for J. Salmon from the 1920s to the 1940s. She is mentioned in the obituary of her daughter, who was also an artist, but not much is known about her.

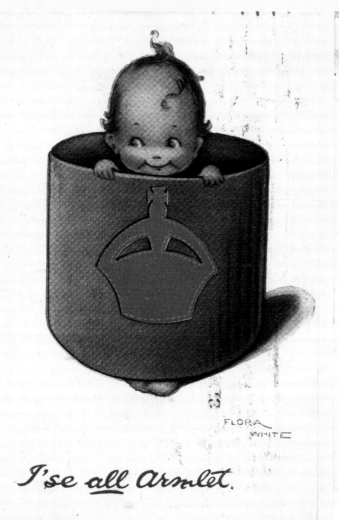

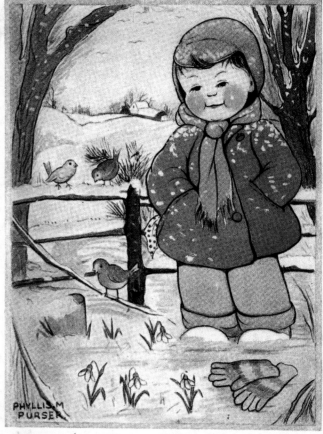

LEFT © Flora White, 'I'se all Armlet'. Postcard, September 1916. Roger Mayhew. The Derby Scheme armlet was worn by men in reserved occupations during WWI to signal that they were not shirking their duty.

RIGHT © Phyllis M. Purser, 'Some chaps wonder…', c. 1930s. Postcard printed by J. Salmon. Cartoon Museum, London.

Women in the press

'I received a letter once asking me if I was "really a woman... [because] your work is so good... or is the name Nicola just a conceit?"' – Nicola Jennings

From the 1920s, a few women cartoonists began to appear regularly in print, and British news publications carried plenty of women's cartoons throughout the twentieth century. Annie Harriet Fish, Victoria Davidson, Margaret Belsky, Antonia Yeoman and other artists were published in magazines such as *Lilliput*, *Punch*, *Eve*, the *Daily Sketch* and the *Daily Herald*. The practice at the time was for artists to sign with their surname, so most readers were unaware of the cartoonist's gender. Not many women cartoonists' names come to mind immediately for the general reader of these periodicals and newspapers today, despite many having had a long career in cartooning, or, in the case of Mary Tourtel, having been responsible for creating one of Britain's best-known cartoon characters, Rupert Bear.

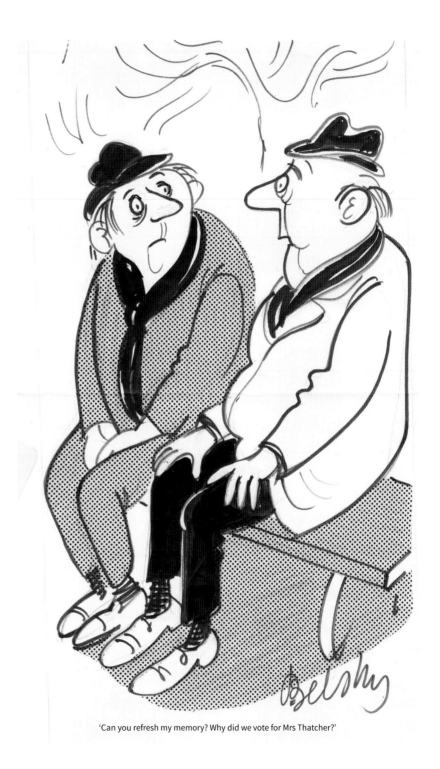

'Can you refresh my memory? Why did we vote for Mrs Thatcher?'

ABOVE © Margaret Belsky, *Sunday People,* 1980. Cartoon Museum, London.

Mary Tourtel
(1874–1948)

Mary Tourtel was already an established artist and author, when, in 1920, she created a character called 'Little Lost Bear' as a daily cartoon strip for the *Daily Express*. The character would go on to be better known as Rupert Bear. Between 1920 and 1935, Mary wrote and illustrated many Rupert stories, which were reproduced in a series of very successful books. Rupert was originally cast as a brown bear until the *Express* cut inking expenses, giving him his iconic and characteristic white colour. Failing eyesight forced Tourtel to stop drawing Rupert in 1935.

Helen McKie
(1889–1957)

Staff artist for *The Bystander* magazine from 1915 to 1929, McKie also contributed to other magazines such as *The Sphere*, *Autocar* and *Queen*. She illustrated books, created mural designs and painted the artwork for posters. Unusual in that she was a roving reporter, not confined to a studio, McKie did a lot of vignettes during the First World War focusing on people, soldiers, women and the war effort. After the war she seems to have been quite the girl about town, sending back drawings from the Riviera and sketching scenes at London nightclubs.

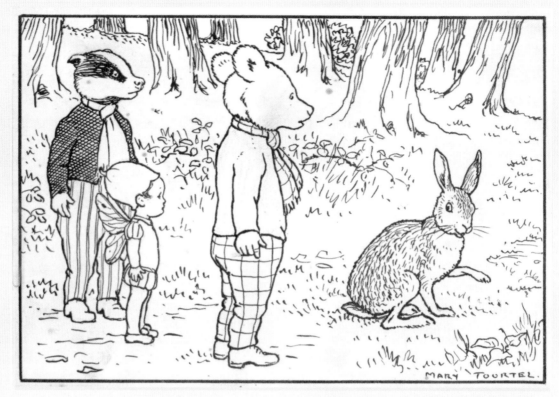

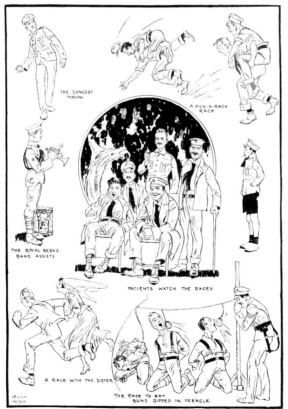

ABOVE Mary Tourtel, 'Rupert and the Fairy Child', 1921. *Daily Express*.

BELOW © Illustrated London News Ltd/Mary Evans. Helen McKie, 'Canadian "Convalescent" Competitions', 1918. Sketches of a day's sports amongst soldiers at their convalescent hospital. *The Bystander*.

Gladys Peto
(1890 –1977)

Gladys Peto was known for her humorous illustrations for 'Letters of Phrynette' in *The Sketch* magazine, which was a rival gossip column to *Tatler*'s 'Letters of Eve'. She also illustrated children's books, designed postcards and produced advertising images.

Annie Harriet Fish, 'Fish'
(1890–1964)

Annie Harriet Fish began contributing to American *Vanity Fair* and *Vogue* from around 1913 and, later, *The Sketch*, *Eve*, *Punch* and *Tatler*. For *Tatler* she created the social satirical strip cartoon 'The Adventures of Eve', 'drawn by Fish and written and designed by Fowl'. The character she created, Eve, inspired not only a stage revue featuring the character wearing costumes designed by Annie, but also 12 silent comedy films from Gaumont in 1918 on popular war themes. Her strips were collected in three Eve books and her style was also used in advertisements for her husband's textile firm. She created a number of covers for *Tatler* during the First World War, and her illustrations of night spots for Eve suggests she was very much at the heart of smart 1920s society.

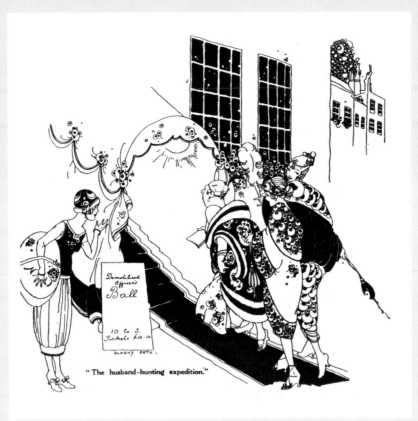

"The husband-hunting expedition."

LEFT © Illustrated London News Ltd/Mary Evans. Gladys Peto, 'A husband hunting expedition', 1919. Ladies eagerly arrive at a ball for demobilised officers. The title is a comment on the dearth of single men at the end of WW1. Illustration to accompany Phrynette's 'Letter from London' by Marthe Troly-Curtin in *The Sketch* magazine.

BELOW © Illustrated London News Ltd/Mary Evans. Annie Harriet Fish, 'Eve goes to the cinema', 1918. Eve, and her beau, Reggie, are shown into a cinema by an usherette and are pleasantly surprised to see how dark the auditorium is. Cinemas were considered potential dens of iniquity during WW1.

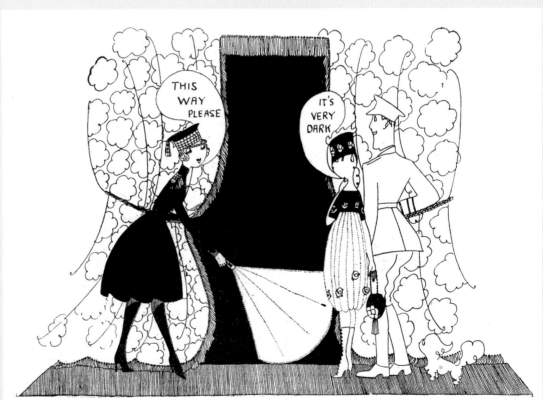

Eve and the reckless one arrive at the pictures, and are swallowed up into an impenetrable and sympathetic darkness—

Victoria Davidson
(1915–1999)

Victoria Davidson was born Lilli Ursula Barbara Commichau in Bavaria in 1915. She worked as a freelance artist from her late teens, coming to Britain in 1935. Her work regularly appeared in *Lilliput*, *Picture Post*, *Radio Times*, *Tatler*, the *Illustrated London News*, *Sunday Mirror*, *Advertisers Weekly*, and the *Daily Sketch*. She also designed posters for London Transport.

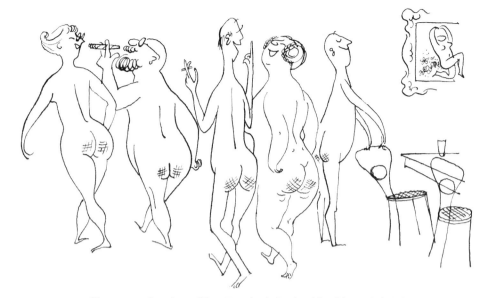

'Everyone rose. It was impossible not to notice the imprint of the wicker-work chairs.'

ABOVE Victoria Davidson, 'Gulliver among the nudists', 1949. *Lilliput*'s Holiday Special. Cath Tate collection.

Margaret Belsky, 'Belsky'
(1919–1989)

Margaret Belsky began drawing cartoons while she was a student at the Royal College of Art, signing herself as 'Belsky'. From 1951 to 1969 she drew a front-page political pocket cartoon for the *Daily Herald* (later *The Sun*). Despite being the only daily woman cartoonist at the time, Belsky resigned when Rupert Murdoch took over the paper. Her work also appeared in *Men Only*, *Punch*, the *New Statesman*, *Sunday People*, *The Guardian* and the *Financial Weekly*. In the early 1960s, she claimed that she was 'addicted to drawing and food' and 'allergic to fast cars'.

Belsky Daily Herald

"I've got something interesting to tell you, but perhaps we'd better go inside the House."

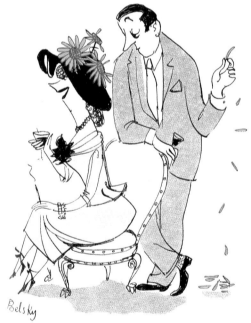

She loves me—she loves me not.

LEFT © Margaret Belsky, 'I've got something interesting to tell you, but perhaps we'd better go inside the House', 1950s. *Daily Herald*, from *British Cartoonists Album No 2*, ed. Ian J Scott, 1963.

ABOVE © Margaret Belsky, 'She loves me – She loves me not'. *Men Only*, February 1950.

Antonia Yeoman
née Thompson,
'Anton'
(1907–1970)

'Anton' attended the Royal Academy Schools before turning to commercial art. She initially produced cartoons with her brother Harold in the late 1930s under the pseudonym 'Anton' but after the Second World War she took over the name herself. She produced cartoons for *Punch*, *Tatler*, the *New Yorker*, *Lilliput*, the *Evening Standard* and *Private Eye*. Her drawings of spivs, forgers, dukes and duchesses were very popular. She illustrated 17 books and produced two collections of her own cartoons: *Anton's Amusement Arcade* in 1947 and *High Life and Low Life* in 1952. She was the only female member of *Punch*'s Toby Club.

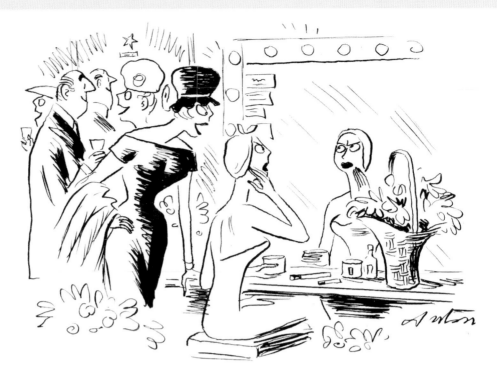

'You were tremendous, darling. Offhand I can't think of anyone who can play the older woman part better than you',

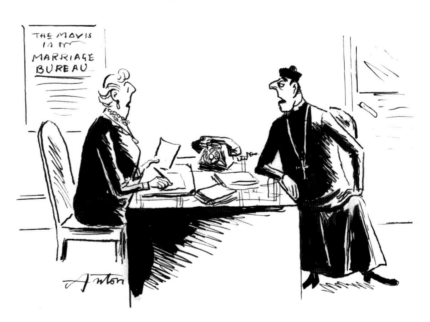

'Let me put it this way. I don't want to be caught entirely unprepared if at some future date we are permitted to marry.'

TOP © Anton, 'You were tremendous, darling', c. 1950. Publication unknown. Patrick Holden collection.

BOTTOM © Anton, 'Let me put it this way…', 1970. Publication unknown. Kate Charlesworth collection.

Sally Artz
(1935–)

Sally Artz was born in London and studied at Saint Martin's School of Art. She has been a professional cartoonist since 1956, contributing to *Punch*, *Private Eye*, *The Spectator*, Mirror Group Newspapers and *The Oldie*, among many other publications.

In a nod to the feminist movement, the March 1972 edition of *Punch* magazine was billed as the New Women's issue, featuring an all-women cast of writers, editors and cartoonists. Sally Artz was commissioned by the guest editor, the redoubtable Barbara Castle, to produce a full-colour front cover but it was relegated to an inside page. The cover went instead to a male cartoonist. Sally says about the replacement: 'More Donald McGill than *Punch* with a huge, bosomy woman (accompanied by tiny hen-pecked husband) being shown the wine-label, in a restaurant, by the leering wine waiter. We were all pretty pissed-off by the whole MCP [male chauvinist pig] attitude. How times change!'

She is a member, and former vice-president, of the British Cartoonists' Association and recently received the 2017/2018 Cartoon Arts Trust's Pont award for 'Drawing the British Character'.

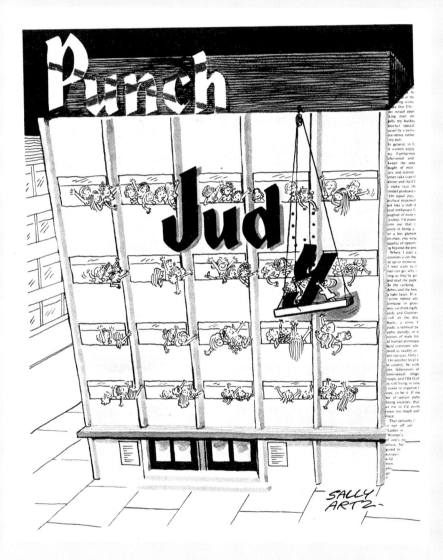

ABOVE © Sally Artz, 'Libby – The Adventures of a Liberated Wife', 1978. This strip ran in the *Sunday People* from 1971–1981.

BELOW © Cover of *Punch* by Sally Artz, 1972.

Pat Drennan
(1933–)

Pat Drennan studied at Belfast College of Art, 1950–55. Her first cartoon was published in the *Daily Mirror* in 1978, and she subsequently contributed to many national dailies and magazines, including *Punch*. She created advertising cartoons for a variety of clients, principally Fortnum and Mason (1982–1992) and won first prize in the Waddington's Cartoon Awards (1988). Most recently she drew 'The Lady Laughs' for *The Lady* (2000–2009).

'My cartooning career started in 1978 when I was looking for an alternative to my part-time job as a reluctant art teacher. My husband persuaded me to send some drawings off to a syndicate and I was surprised and delighted to sell my first cartoon for £6. At that time, the Golden Age of Cartooning, it was relatively easy to get work published, and my cartoons were soon appearing in national papers and magazines.'

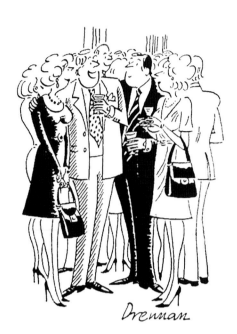

"I think we're over the worst! Our boy's out of Transcendental Meditation and into accountancy!"

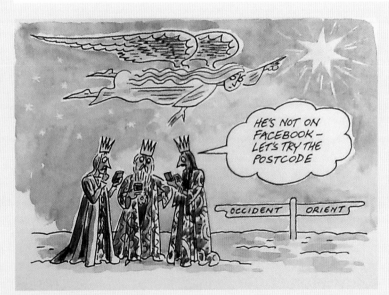

ABOVE © Pat Drennan, 'I think we're over the worst! Our boy's out of Transcendental Meditation and into accountancy!'. From *A Kid's Guide to Parents*, Richard Drew Publishing Ltd, 1982.

BELOW © Pat Drennan, 'He's not on Facebook', 2014. Privately commissioned Christmas card.

Riana Duncan

(1950–)

Riana Duncan is a joke cartoonist, writer and illustrator who was born in Scotland and studied graphics in The Hague. She began cartooning in the late 1970s. Her work appeared in *The Spectator*, *Men Only*, *The Guardian*, *Punch* and *The Observer*. Her books include *History and Her Story* (1986) and *Not Tonight: A Cartoon Guide to Sex and the British* (1987). She now lives in France.

RIGHT © Riana Duncan, 'That's an excellent suggestion, Miss Triggs. Perhaps one of the men here would like to make it.' *Punch*, 1988.

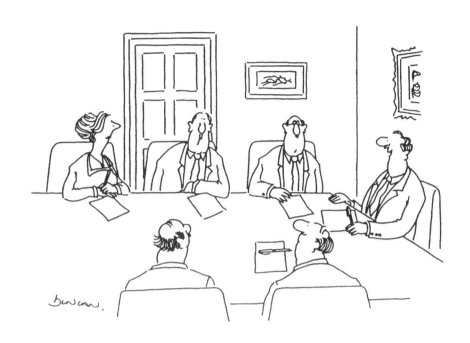

'That's an excellent suggestion, Miss Triggs. Perhaps one of the men here would like to make it.'

Rosemary Dulak

Rosemary Dulak's cartoons regularly appeared in *She*, *About Town*, the *Daily Sketch*, *Daily Mirror* and *Sunday Telegraph*. In 1964, she took part in a BBC2 panel discussion of Simone de Beauvoir's *The Second Sex* by 'women who compete successfully as equals with men in their own fields'. As this cartoon shows, she was already raising questions about women's position in the world in 1964.

RIGHT © Rosemary Dulak, 'Pills', 1964. From *Rosemary for Remembrance*.

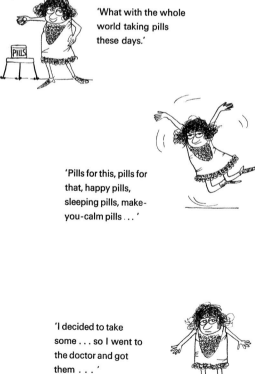

Merrily Harpur

Merrily Harpur has worked as a freelance cartoonist for *The Guardian*, *Punch*, *The Times*, the *Sunday Telegraph*, *The Listener*, *Field*, *Country Living* and others.

'I have enjoyed every minute of it – laughing at your own jokes being the ideal day at the office. Out of office hours, I prefer laughing at other people's. I now also paint in oils, mainly the landscape of Dorset, where I now live.'

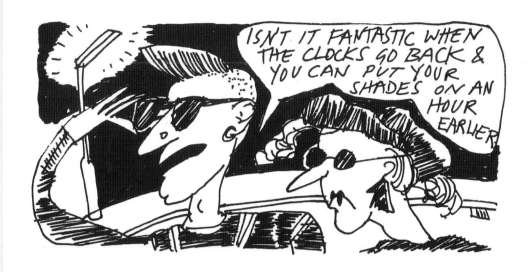

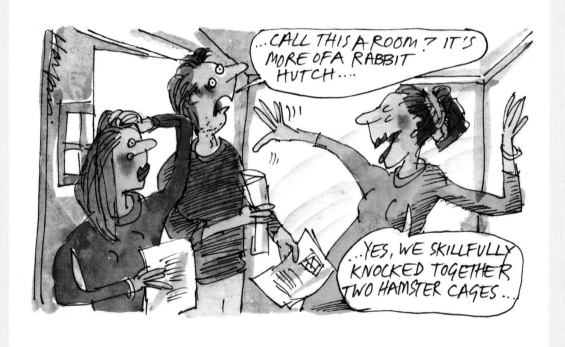

ABOVE © Merrily Harpur, 'Isn't it fantastic when the clocks go back & you can put your shades on an hour earlier.' *The Guardian,* 1991.

BELOW © Merrily Harpur, 'Call this a room? It's more of a rabbit hutch.' *Evening Standard* property section, 2016.

Judith Walker

(1955–)

Judith Walker, also a fine artist, was born in Leeds. She started drawing cartoons for *Duck Soup* cartoon magazine in the mid-eighties. She produced a strip cartoon for *The Sun*'s women's section, called MEN! from 1987–90 and was an editorial cartoonist for the *New Humanist* magazine 2006–13. In 2014 she was cartoonist in residence at University College London Hospitals.

Sally Ann Lasson

Sally Ann Lasson studied at Saint Martin's School of Art and has worked as a cartoonist since 1986, as well as an illustrator, a journalist and an interior designer. From 1999 to 2011 she had a daily strip, 'As If' in *The Independent*. Apart from illustrating books by other people, she has had collections of her own work published: *That Old Chestnut* in 1989 and *As If* in 2004. She is currently writing a graphic novel in New York.

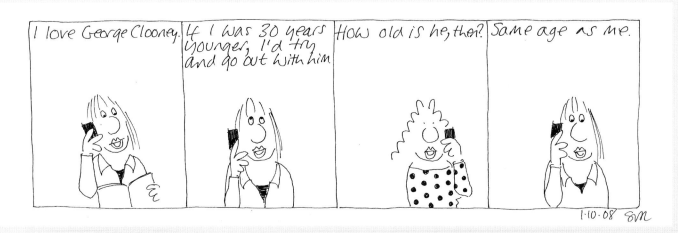

ABOVE © Judith Walker, 'MEN!', *The Sun*, 1989.

BELOW © Sally Ann Lasson, 'I love George Clooney'. *The Independent*, 2008.

Nicola Jennings

Nicola Jennings originally trained as a theatre designer and started work designing for opera. She began caricaturing for the *London Daily News* in 1987, went on to work for the *Daily Mirror* and *The Observer*. She draws caricatures and political cartoons for *The Guardian*. She has also produced animated cartoons for Channel 4's 'A Week in Politics' and drawn live on BBC2's 'Midnight Hour'.

'I received a letter once asking me if I was "really a woman... [because] your work is so good... or is the name Nicola just a conceit?" I am glad he thought my work was good. I have a sense that the editorial political cartoon is a centuries-old boy's club. I wonder whether men find it uncomfortable to be lampooned by women. It may be felt as criticism, whereas men poking fun at each other seem to be sharing an in-joke, a slap on the back.'

BELOW © Nicola Jennings, 'Trump Tweets'. *The Guardian*, 2017. Commissioned as an editorial cartoon in response to the day's news. In early January 2017, leading Republicans had been made uneasy by President-elect Donald Trump's tweets, in which he had expressed support for WikiLeaks founder Julian Assange and Russian president Vladimir Putin.

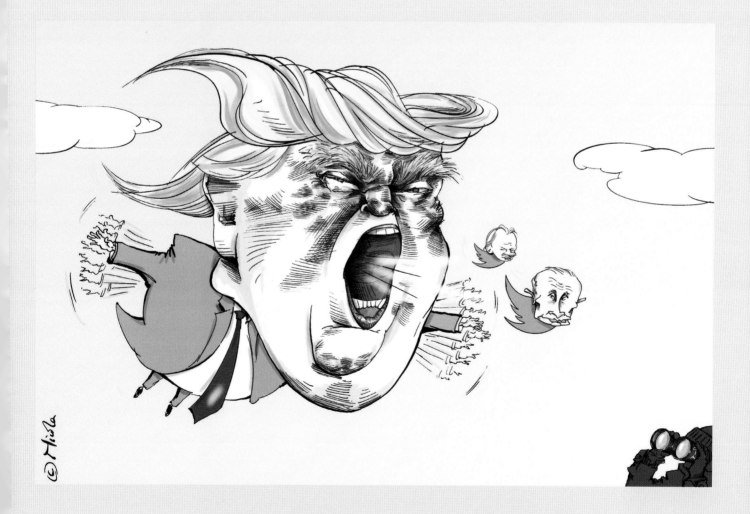

Louise McKeever
aka Bluelou
(1971–)

Bluelou's work was published in *The Guardian* in August 2010, covering for Steve Bell and Martin Rowson.

She was the first woman to enter the Political Cartoon Awards in 2012. In 2014, she was the first woman to have work included in the anthology, *The Best of Britain's Political Cartoons*, when her cartoon was allegedly voted into the top five for the 'Cartoon of the Year'. Her cartoons have appeared in *The Guardian*, *Morning Star*, *New Statesman*, and the *Times Education Supplement* and she is currently employed by *The Tribune* magazine.

Ella Bucknall
(1993–)

Ella Bucknall was born in Bow in East London and grew up in Stockport. Ella is an Oxford English graduate and is currently studying for an MA in Illustration at Camberwell College of Arts. Ella founded *WHIP* zine, a new zine of political cartoons and satirical writing created entirely by women, in June 2017.

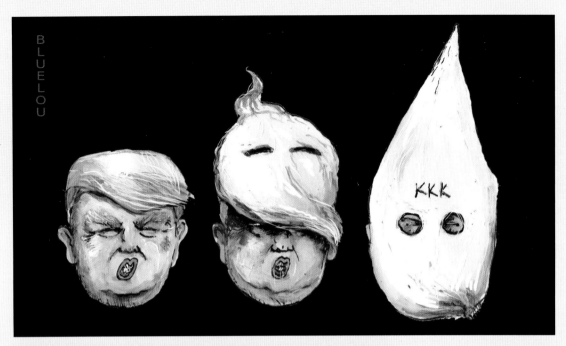

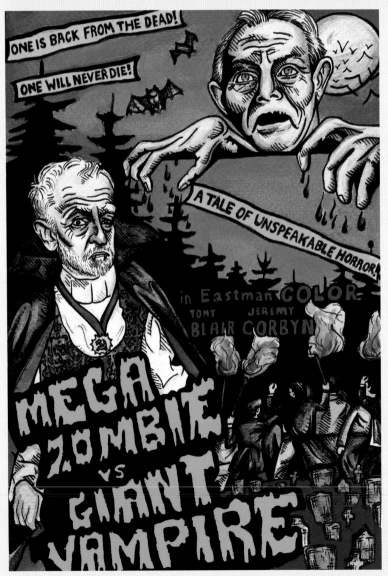

TOP © Bluelou McKeever, 'KKK', *The Tribune*, 2016.

LEFT © Ella Bucknall, 'Mega Zombie vs Giant Vampire', *WHIP* zine, Issue 1, 2017. A response to Tony Blair's criticisms of Jeremy Corbyn in the early stages of general election campaigning.

Martha Richler

(1964–)

Martha Richler was born in London and has lived and worked there as a political cartoonist since 1996. She uses the pen-name 'Marf'. She studied art history at Harvard, Columbia and Johns Hopkins and was a Lecturer at the National Gallery of Art, Washington. She was the *Evening Standard*'s chief editorial cartoonist and, since 2008, has worked as editorial cartoonist for PoliticalBetting.com. She draws editorial cartoons for *The Jewish Chronicle*.

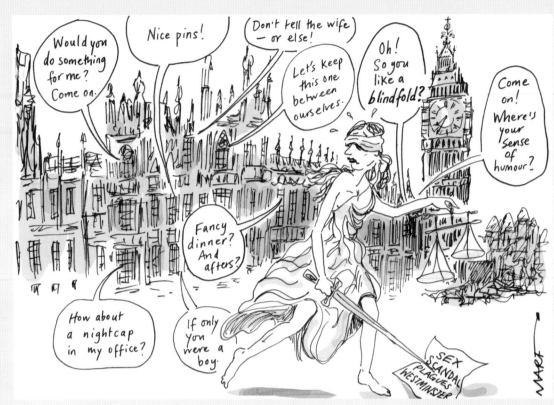

ABOVE © PoliticalBetting.com. Martha Richler, 'Lady Justice Being Harassed at Westminster', 2017. Drawn on the night of 2 November 2017, published on the morning of 3 November 2017.

The Surreal McCoy

Work by The Surreal McCoy has appeared in *The Sunday Times*, *The Independent*, *London Evening Standard*, *London Jewish News*, *Reader's Digest*, *The Spectator*, *Prospect*, *The Oldie*, *Fortean Times* and elsewhere. Books include *Girls Are Best* by Sandi Toksvig and *Alex Through The Looking Glass* by Alex Bellos. McCoy has also been cartoonist-in-residence on Sandi Toksvig's daily radio show for LBC.

'Originally I am a musician but later became an accidental cartoonist. When not performing I can now be found drawing. I began drawing cartoons about 20 years ago while on tour with a band during a particularly long bus journey across America.'

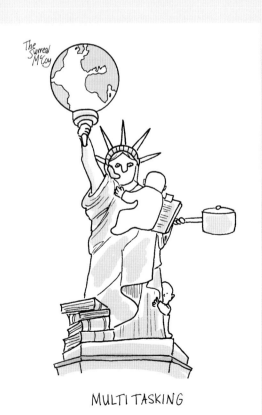

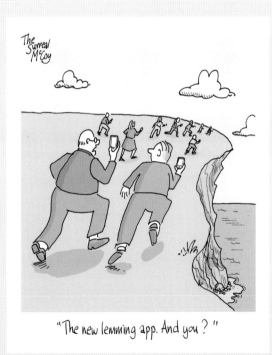

LEFT © The Surreal McCoy, 'Multitasking'. Illustration for *Girls Are Best* by Sandi Toksvig, Random House, 2008.

ABOVE © The Surreal McCoy, 'Lemming App'. *Prospect*, 2013.

Bev Williams
(1939–2016)

Bev Williams was born in New Zealand. She produced a regular cartoon column for the *Daily Express*. In the early 1990s, having noticed a gap in the market for cards which reflected the attitudes and humour of the post-war generation, she created the 'Spring Chicken' range of greeting cards. Her cartoons also appeared on a wide selection of merchandise.

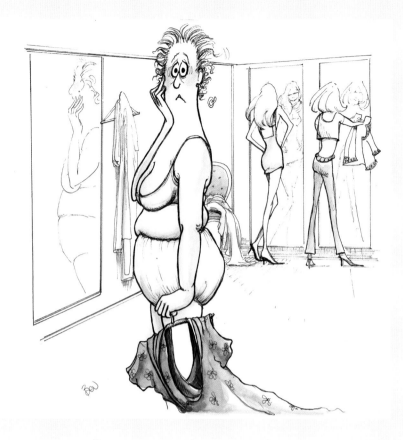

LEFT © Bev Williams, 'Mirror mirror on the wall, I am my mother after all'. Greeting card design, BW Cards.

Sue Macartney-Snape
(1954–)

Sue Macartney-Snape was born in Tanzania, grew up in Australia and arrived in London in 1980. She has had many commissions, including from Glyndebourne and The Metropolitan Opera. Between 1994 and 2011 she drew the characters in the Saturday *Telegraph* Magazine's 'Social Stereotypes' column. In 2004 she won the Cartoon Art Trust's Pont Award for drawing the best British Character.

RIGHT © Sue Macartney-Snape, 'The Emergency Pee'. *Daily Telegraph,* c. 2006.

Annie Tempest
(1959 –)

Annie Tempest's first book *How Green are your Wellies?*, published in 1985, led to a regular cartoon, 'Westenders', in the *Daily Express* and, later, 'The Yuppies' in the *Daily Mail*. Since 1993, her 'Tottering-by-Gently' strip has run in *Country Life* magazine. In 2009 she won the Cartoon Art Trust's Pont Award for drawing the best British Character. She lives in rural Norfolk with her dog.

'I originally became a cartoonist because I was underemployed as a secretary and took up knitting which my boss said looked unprofessional. He told me to read like normal people. As I am dyslexic, I said that wasn't an easy option, so he said teach yourself to draw then.

I did, from "how to" books borrowed from the Kensington and Chelsea library. I studied at night. I was trying to draw seriously, but never felt they looked any good so to make them more acceptable, I wrote little humorous lines under them. People started commissioning me to do cards for them and the rest is history. Over the next year, I morphed from secretary into working cartoonist. I still cartoon every day.

'The only time I was aware of being a woman in what was a man's world was when I won the Strip Cartoonist of the Year award for 'The Yuppies' in the *Daily Mail* in about 1989. There was only one other woman in the room and all the men were old. I won an engraved whisky decanter!… and some money'.

ABOVE © Annie Tempest @ Tottering by Gently, 'THE FEMALE CHARACTER – The ability to see facts from whichever angle suits them best', 1999. Postcard for The O'Shea Gallery, London.

BELOW © Annie Tempest @ Tottering by Gently, 'The older I get the more I like it'. *Country Life*.

THE FEMALE CHARACTER – The ability to see facts from whichever angle suits them best…

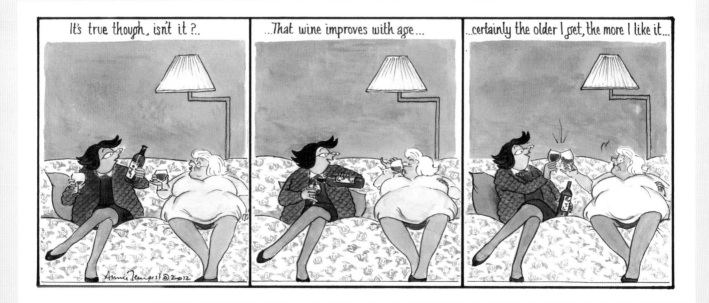

Kathryn Lamb
(1959–)

Kathryn Lamb started drawing cartoons for *Private Eye* in 1979 while she was a student at Oxford reading English Literature. Self-employed, she has written and illustrated children's books to supplement her income. She illustrates Pseuds Corner in *Private Eye*, and contributes topical and non-topical cartoons. Her work also appears in *The Spectator* and *The Lady*. She also brought up six children on her own.

'I grew up reading and greatly appreciating *Private Eye* – and was also fascinated by a book showing the history and evolution of *Punch* cartoons through the decades. I always loved drawing – and writing stories. Creating my own characters and letting my imagination run freely was also a refuge after a period of bullying at a school in the UK. I am very anti-bullying – in all its forms.

'I will continue to cartoon as long as I can. I no longer get asked "And when are you going to get a proper job?" – which is a relief!'

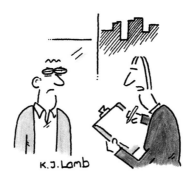

'ON A SCALE OF 1-10 , HOW IRRITATED ARE YOU AT BEING ASKED TO RATE THINGS ON A SCALE OF 1 - 10 ? '

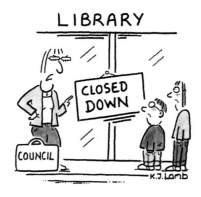

'IT SAYS "CLOSED DOWN" – CAN'T YOU READ ? '

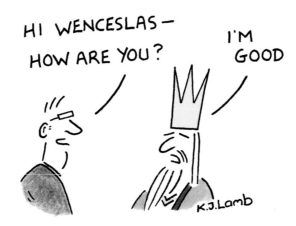

TOP © Kathryn Lamb, 'On a scale of 1–10', 2017. Greetings card, Cath Tate Cards. Originally in *The Spectator*.

MIDDLE © Kathryn Lamb, 'Closed Down', 2017. Greetings card, Cath Tate Cards. *Private Eye*, issue 1278. Reproduced with kind permission of *Private Eye* magazine / Kathryn Lamb.

BOTTOM © Kathryn Lamb, 'Hi Wenceslas', 2017. Greetings card, Cath Tate Cards. *Private Eye*, issue 1314. Reproduced with kind permission of *Private Eye* magazine / Kathryn Lamb.

Ros Asquith

Ros Asquith always drew as a child and then self-published a book of cartoons about dogs, which sold at Crufts dog show 'on a little tray like an ice-cream seller'. It made a profit. She left school at 16 and studied graphic design. 'My first job, aged 17, was illustrating Greek myths. I worked as a photographer, mural painter, prop maker, art teacher and many other things. It was only when I started in journalism that I realised everyone else in the field had been to university, which was quite a shock.

'I drew 'Doris' for *The Guardian* from 1988 to 1998. Doris was inspired by the idea of the silent woman – the cleaner, grandmother, whoever – who keeps society's wheels oiled but goes unnoticed. Doris never speaks, only thinks. She satirises the chattering classes, I hope. Her employers are caricatures of selfish media types. An ex-convict once said he loved Doris: "My mum was a cleaner, I used to sit in little Tarquin and Amanda's nursery while she polished and scrubbed for them. I couldn't wait to grow up and rob the lot of them."'

Asquith has written and illustrated about 90 books for young people and cartooned for *The Guardian* and others for over 20 years. She is currently cartoonist-in-residence at University College London Hospitals, thanks to the Wellcome Trust.

RIGHT © Ros Asquith, 'Doris diets 1984', *The Guardian*.

BELOW © Ros Asquith, 'Condom on the Patio'. Postcard, Cath Tate Cards. Originally published in *Toddlers* by Ros Asquith, Pandora Press, 1982.

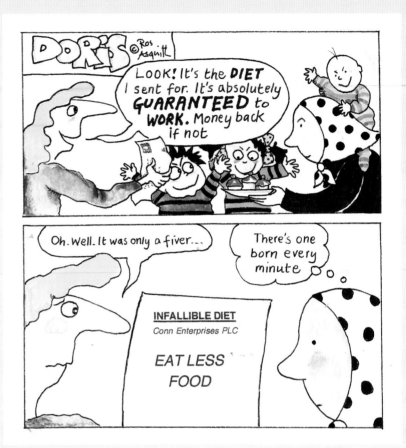

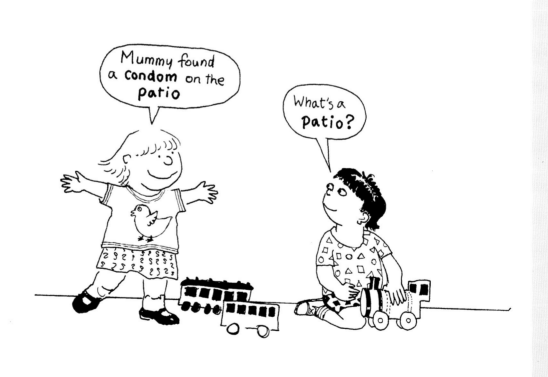

Posy Simmonds
(1945–)

'I've always liked the combination of words and pictures. I began drawing comics as a child, around 1954 – inspired by the comics given me by American children in the village where I grew up. It was not long after the war and there were still US Air Force families stationed there. The children would go to an airbase every Saturday, returning with armfuls of comics – among them *Superman*, *Mickey Mouse*, *Casper the Ghost*, *Sad Sack*, *Blondie & Dagwood*, *Little Nancy*; there were also torn out strips from papers, like *Dick Tracy*, *Krazy Kat*. And some horror comics. My Proustian moment would be hot sun, long grass, dozing under an American comic… the smell of the ink…

'I would be constantly asked (by men): "Why aren't women funny? Who thinks of your ideas? Can you draw properly if you want to? What else do you do?" In the bad old days, there were men who assumed you'd had work published by fluttering your eye-lashes… in fact they thought that was how all women got jobs (apart from the womanly occupations like nursing and teaching).

'In the early 1970s, the magazine *Punch* had mainly male writers and cartoonists. Even though there were a few women working for it, they were excluded from the weekly *Punch* lunch: five courses, wines, liqueurs, cigars, everyone blootered by 4pm. One day in the early 1970s, the editor thought it a wonderful idea to find out about "Women's Lib" and to

have a special Women's Issue. Women would be invited to contribute, but could not be trusted with any editing. I was among a number of women invited to participate. We repaid the editor's great condescension by picketing the *Punch* office – the Labour MP Barbara Castle headed the demo, police were called, the press came. Afterwards, the Women's Issue was entirely produced by women and the *Punch* table ceased to be men-only. A tiny victory.

'Now that there are so many more women working in comics, the depiction of women in cartoons/comics has changed. The old cast of stereotypes still exists (pneumatic bimbo, pneumatic vamp, nag in an apron) but more often females are now given characters, rather than

sexual characteristics. Thank goodness.

'I have worked as a freelance cartoonist/illustrator since 1969. It was very hand-to-mouth to begin with, working as a cleaner and dog-walker to make ends meet. In 1972 I began drawing for *The Guardian*, an association which continued for 40 years, including a weekly strip (1977–87) and two serials, 'Gemma Bovery' and 'Tamara Drewe'.

BELOW © Posy Simmonds, 'The Bunns', *The Guardian*, 1976. Many of Posy's early cartoons, including this one, appeared alongside articles by the journalist Jill Tweedie.

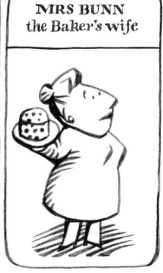

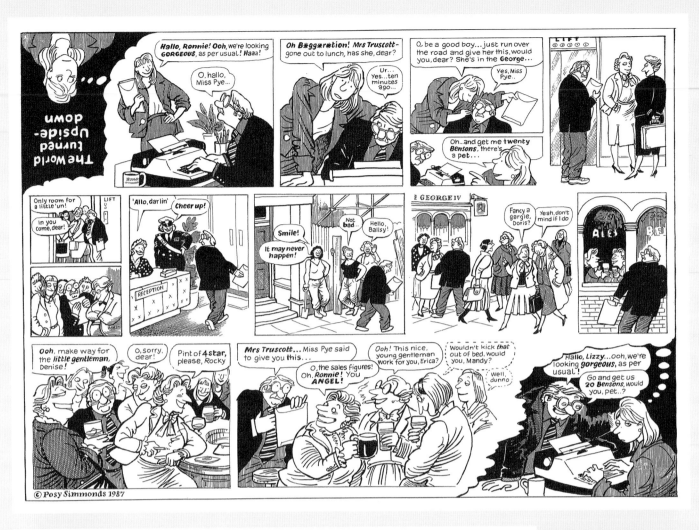

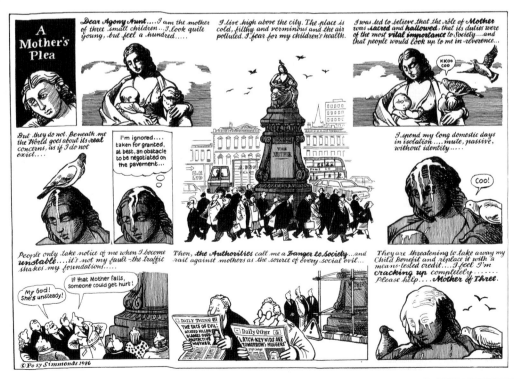

ABOVE © Posy Simmonds,
'The world turned upside-down',
The Guardian, 1987.

LEFT © Posy Simmonds,
'A Mother's Plea', *The Guardian*,
1986.

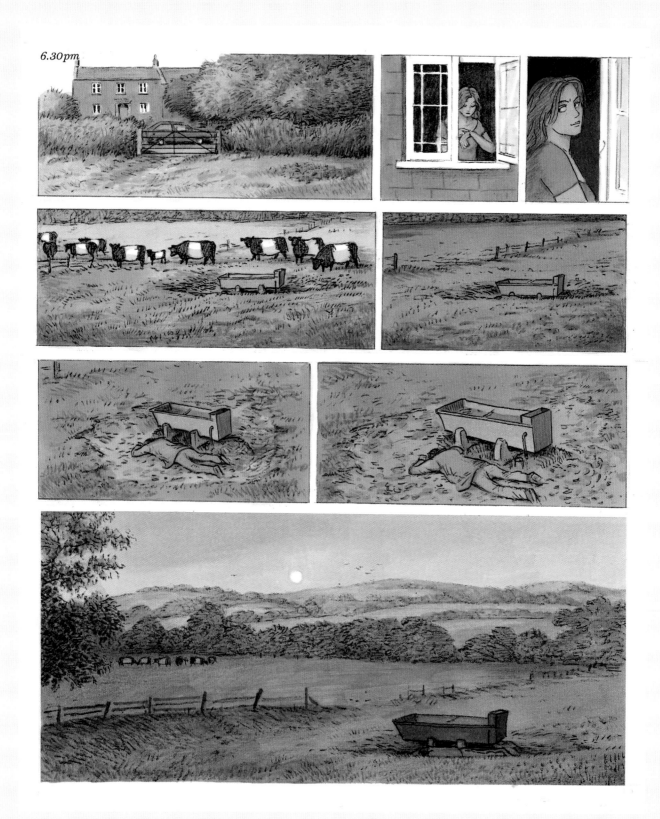

Counter-culture and the Women's Liberation Movement

Nicola Streeten

During the 1970s, the changing political atmosphere introduced a radicalism that should have welcomed and supported women in all areas, including cartooning. The activity of so-called counter-culture did not extend to an understanding of or an engagement with feminism, and was often openly sexist. However, women began using their visual skills to support the revival of feminism through the Women's Liberation Movement (WLM). The call was for women to be taken seriously, although the imagery was often humorous. In 1971, the four demands of the WLM were: equal pay; equal education and job opportunities; free contraception and abortion on demand; and free 24-hour nurseries. Three additional demands were added later: financial and legal independence (1974); an end to discrimination and freedom from intimidation by threat or use of violence or sexual coercion, regardless of marital status (1974); and an end to all laws, assumptions and institutions, which perpetuate male dominance and men's aggression towards women (1978).

The See Red Women's Workshop (1974–1990)
In 1974 three ex-art students, Pru Stevenson, Suzy Mackie and Julia Franco, formed the women's screen-printing collective in London. SRWW worked with more than 40 women over 16 years. Like the suffrage campaigners, they used a quick, affordable, printing technique to produce posters and leaflets to support feminist campaigning. The portability of screen-printing enabled them to print at local and national events such as the Annual National Women's Liberation Conference 1975.

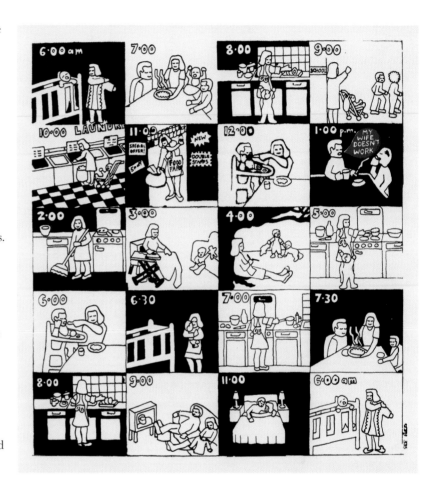

ABOVE © See Red Women's Workshop, 'My wife doesn't work', 1976. See Red produced posters to further the cause of the Women's Liberation Movement to subvert, explore and challenge the stereotypical role of women within the male art world.

The underground press
From 1966, the underground or alternative press emerged in Britain with a reputation for challenging the status quo. Publications included *International Times* (1966–1973), *Oz* (1967–1973), *Black Dwarf* (May 1968–1972), *Frendz* (1969–1972) and *Ink* (May 1971–1972). There were women contributors, including Germaine Greer and Sheila Rowbotham, who was an editorial member of the Marxist newspaper *Black Dwarf*. But where such publications featured cartoons, they were by artists such as Robert Crumb and Gilbert Shelton and women cartoonists were scarce. An exception was artist Nicola Lane who was the only woman cartoonist for *International Times* (*IT*).

Nicola Lane

(1949–)

Nicola Lane graduated from art school in 1972 and since then has worked continuously as a professional artist. Her creative practice began with painting, illustration, and comics and cartoons for the 1970s underground press, and has evolved into film-making and installation. She lives and works in London.

'As I opened my portfolio to show an upmarket art dealer in Bond Street, he said jovially: "You girls are so clever with your portraits, aren't you!" and then when he started to look at the photographs of my work his expression changed abruptly. "Oh" he said in a flat voice, "You're good".'

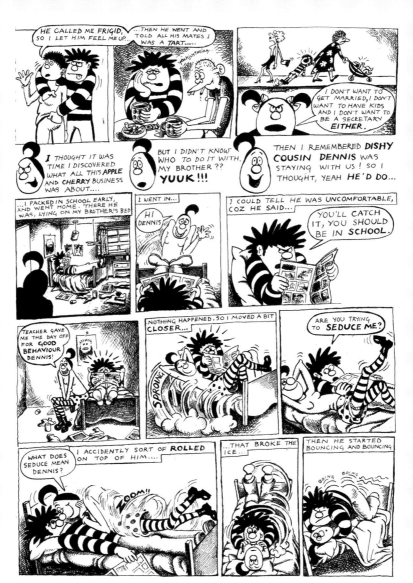

ABOVE © Nicola Lane, 'Frigid', 1980. Commissioned by Beryl and The Perils, a group of women that set up a theatre company in 1978. Their name was inspired by Lane's *International Times* strip. They invited Lane to produce their artwork and, in 1980, commissioned her to create a comic book theatre programme for their 'Is Dennis really the Menace?' show. 'Frigid' is an excerpt.

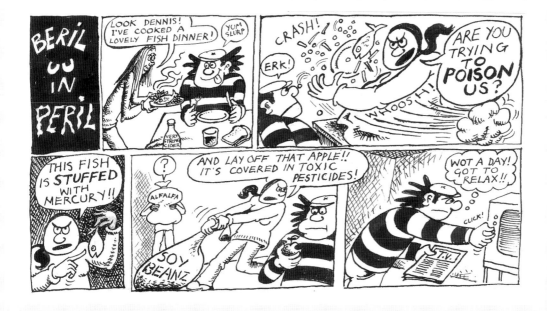

LEFT © Nicola Lane, detail from 'Beryl in Peril' strip, *International Times,* c.1978. Lane's cartoon strip series for the *International Times* was based on the original line-up of characters Dennis the Menace, Beryl the Peril and others from *The Dandy* and *The Beano* comics, but representing them as radical adults.

An alternative mainstream in comics

Nicola Streeten

From the end of the 1960s, the British mainstream comics industry associated with publishers such as Marvel and DC Comics began to decline. A more non-conformist alternative emerged, with successful titles including *2000AD* (IPC/Fleetway, 1977) and *Viz* (House of Viz, 1979). Although inspired by a politics challenging existing social structures, the move was towards a male alternative with little inclusion of women cartoonists. Much later, *Deadline* (owned by Tom Astor, and published 1988–1995) established itself as a platform for new comic talent and included cartoons by women such as Rachael Ball and Julie Hollings.

These titles were typical of a new approach to comics. Influenced by the 1970s punk movement, they were anthologies targeting an older readership and aligning themselves with magazines rather than comics. In 1983, inspired by *RAW,* comics writer and curator Paul Gravett and graphic designer Peter Stanbury launched the magazine *Escape* (1983–1989) with the aim of showcasing new British works. Although comprised mainly of work by male cartoonists, it included some women's cartoons, such as those by Carol Swain and Myra Hancock. One area where wider counter-culture met alternative comics was the Birmingham Arts Lab, which formed in 1973 and had an in-house printing press hand-built and operated by cartoonist Hunt Emerson. Cartoonist Suzy Varty was the only woman member.

The influence of feminist magazine publishing

Spare Rib was undoubtedly the biggest and most important platform for the emergence of women's cartoons. Founded in Britain in 1972 by Marsha Rowe and Rosie Boycott, who had both worked for the alternative press – Boycott at *Frenz* and Rowe at *Oz* and *Ink* – and run as a collective, *Spare Rib* complemented newsletters from Women's Liberation Movement activity which were text-heavy publications with few illustrations or cartoons. Cartoons by women were included from the very first issue of *Spare Rib* until its final issue in 1993. By the end of the 1970s, all issues included a regular double-page cartoon spread, as well as single-panel cartoons.

Pairing imagery with humour to disseminate feminist messages directly links *Spare Rib*'s tactics to those employed in the campaign for women's suffrage. Another similarity to the suffrage artists was a commitment to working collectively, an ethos traceable in women's cartooning as it incorporated a changing Britain over the decades. There are other striking resemblances in production and distribution strategies. Many women producing cartoons for *Spare Rib*, and the numerous feminist publications carrying cartoons that followed, were professionally trained as fine artists. They used their skills to support a political campaign, a motivation that is still detectable in work currently being produced by women today. This trend reflects the educated status of women cartoonists and locates them within a position of privilege. The criticism of white privilege is one that has been levelled at feminism over the years, and is clearly evident as a feature in the British history of women's comics. It is indicative of a wider social structure that continues to demand debate to this day.

Spare Rib was one of a number of magazines circulating news and debate. The WLM had their own newspaper, *Shrew* (1969–1974), published by the Women's Liberation Workshop, which carried women's cartoons. These magazines were circulated at the WLM conferences and demonstrations. This is comparable to the WSPU national newspaper, *The Suffragette* (1913–1918), which included works by the Suffrage Atelier and was distributed through the WSPU national chain of shops. Cartoonists who cut their teeth on *Spare Rib* in the 1970s continued to work for new feminist magazines as they appeared. Four regular contributors included Christine Roche, Jo Nesbitt, Liz Mackie and Lesley Ruda.

Suzy Varty

'My first comic was published in 1975 when I was part of the underground comics collective, and I produced the first British women's comic, *Heroine*, in 1977. I've worked with the medium ever since. I particularly love the way that sensitive issues and comics marry so successfully.'

Varty worked as a graphic designer for community and women's groups. This led her to issue-based work and cartoon workshops. One of her early comics was about contraception, aimed at educating young women in the prevention of teenage pregnancies. British Gas saw it and produced it as a giveaway comic, *Girls' Talk*, printing 90,000 copies.

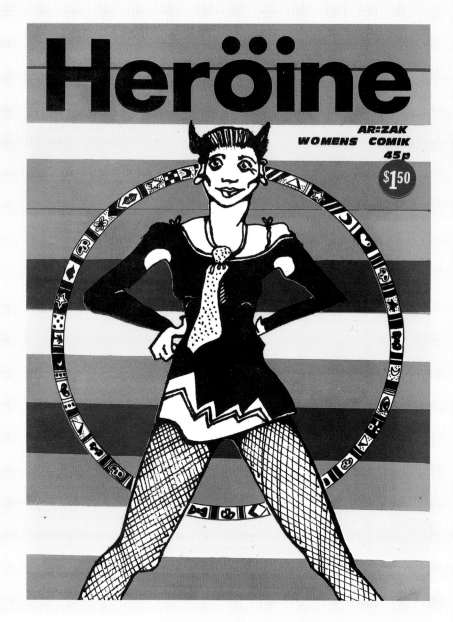

ABOVE © Suzy Varty, front cover of *Heroine*. Ar:Zak, 1978. Varty distributed *Heroine* through feminist networks. Copies were sold at the 1978 Birmingham National Women's Liberation Conference, where it was praised as 'feminist art'. It paved the way for other women's comic collectives and anthologies to follow.

LEFT © Suzy Varty, 'Lasses night out', a comic produced with teenage mothers in North Shields to offer contraception advice to young people.

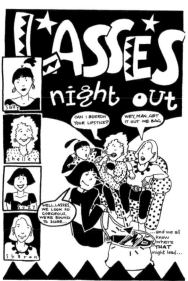

Melinda Gebbie

Melinda Gebbie is a painter, cartoonist, sculptor and writer, who entered the San Francisco underground comix movement in 1973, and left it in 1980.

She worked on the animated anti-nuclear film *When the Wind Blows* in 1985 for TVC London. Her collaborative book with Alan Moore, *Lost Girls*, is an erotic tour-de-force and took 16 years for her to hand draw and colour. It is now available in nine languages.

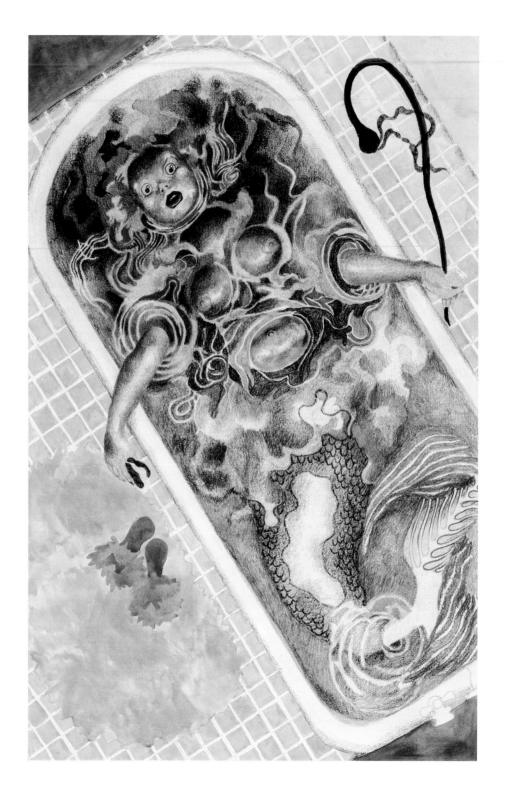

ABOVE © Melinda Gebbie, 'Bath Time', 2001.

Christine Roche

(1939–)

Christine Roche cartooned for *Spare Rib* and went on to refine her feminist politics and cartoonist skills. She worked as illustrator, animator and teacher and joined collectives such as the Kids Book Group for non-sexist/ non-racist/class-aware children's books and the Hackney Flashers, who produced exhibitions on 'Women at Work' and 'Who's Holding the Baby?' by mixing photos, collage, words and cartoons. Roche also co-founded *Sourcream*, a self-publication of feminist cartoonists.

'Politics was at the very root of what I drew and I was lucky not to have to compromise, but then those were different times, agitprop was in the air.'

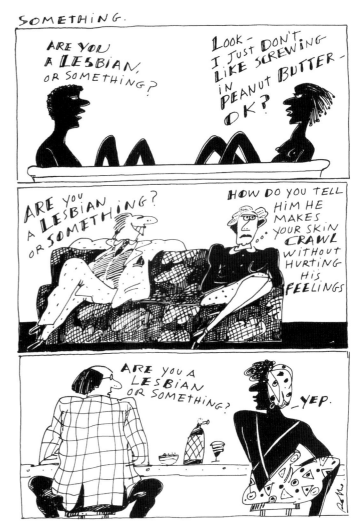

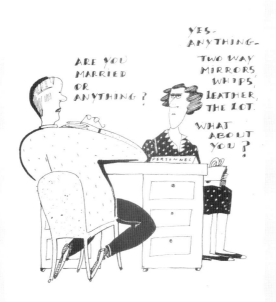

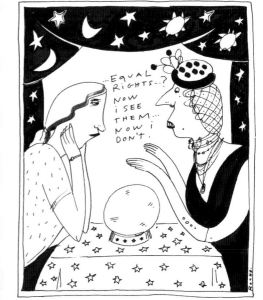

Jo Nesbitt

(1949–)

One of the founder members of *Sourcream* (1979), Jo Nesbitt's cartoons also appeared in *New Statesman*, *Spare Rib*, *Time Out*, *Undercurrents*, *Honey* and *Feminist Review*. She published *The Great Escape of Doreen Potts* (Sheba Feminist Press, 1981), the *Modern Ladies' Compendium* (Virago Press, 1986) and *The Desperate Woman's Guide to Diet and Exercise* (Penguin, 1998). She has lived in the Netherlands since 1982, working as a cartoonist and Dutch-English translator.

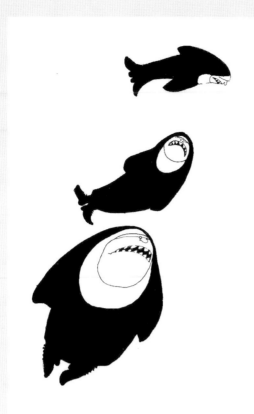

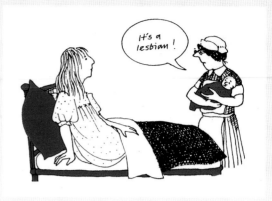

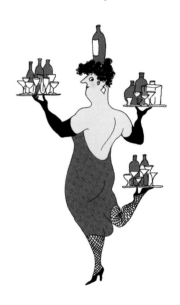

friends will admire the new balanced you.....

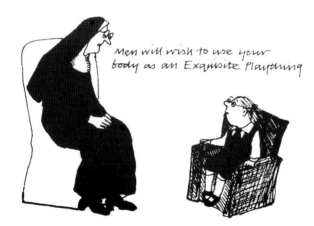

Men will wish to use your body as an Exquisite Plaything

TOP LEFT © Jo Nesbitt, 'Shark nuns', 1979. Design used to decorate the wall of Sisterbite, the women-only café in the women's bookshop Sisterwrite.

TOP RIGHT © Jo Nesbitt, 'It's a Lesbian', 1979. Original postcard, Sheba Feminist Press. Reprinted early 1990s, Cath Tate Cards. This postcard design became a very well-known image of the 1980s, reproduced in a variety of colour ways and in several languages. In the 1980s, the argument over whether sexual orientation was a matter of 'choice' or given at birth was still being debated in British society.

LEFT © Jo Nesbitt, 'Men will wish to use your body as an exquisite plaything', *Sourcream*, Sheba Feminist Press, 1980.

ABOVE © Jo Nesbitt, 'Friends will admire... the new balanced you'. From *Desperate Woman's Guide to Diet and Exercise*, Penguin, 1998. Reproduced in 2017 as a greetings card by Cath Tate Cards.

Liz Mackie

(1940–)

'In the wild, fecund seventies I worked shifts in a left-wing print shop, lived in collective houses and cartooned at night. We breathed left and feminist ideas and the cartoons were part of our exchanges. They belong to the times, not to me.

'Working for a small publisher back in the early days, I slowly realised the pay didn't measure up to the hours spent. I asked what they would do if I asked for more next time. They (he) said they'd find someone else. I did. They did. It wasn't really about gender, just about power.

'I mainly drew my cartoons at night when the day's work was over. To the best of my knowledge, these date from 1972 to 1974 and were first published in *Case Con*, a revolutionary magazine for social workers. They were later reprinted in *Sourcream*, in 1979.'

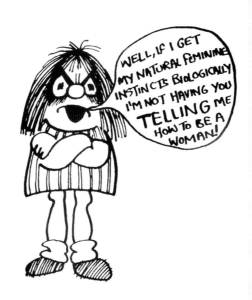

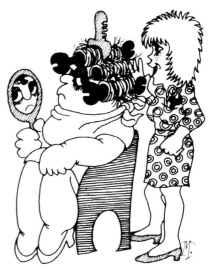

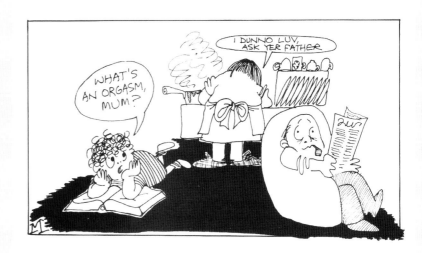

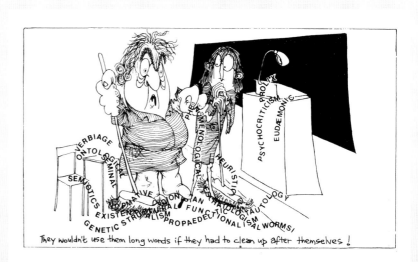

TOP LEFT © Liz Mackie, 'Natural Feminine Instincts'. First published in *Case Con*, c.1972–74. Reprinted in *Sourcream*, 1979.

TOP RIGHT © Liz Mackie, 'I really wanted to be a mechanic, but there were no apprenticeships for women'. First published in *Case Con*, c.1972–74. Reprinted in *Sourcream*, 1979.

MIDDLE © Liz Mackie, 'What's an orgasm, Mum?'. First published in *Case Con*, c.1972–74. Reprinted in *Sourcream*, 1979.

BOTTOM © Liz Mackie, 'They wouldn't use them long words if they had to clean up after themselves', 1968–70.

Lesley Ruda
(1950–)

Lesley Ruda's cartoons were first published in *Spare Rib* in 1976, then in other publications including *Sourcream* in 1979, of which she was a founding member. She found cartooning 'subversive and amusing'. 'It was easy to find material to satirise in the late '70s in the UK, especially around sexism and class division, and all you needed was ink, pens, paper and a desk'.

'The stuff I like experimenting with is seldom what I am asked for in jobs. That was largely the impetus behind doing a self-published book, *Sourcream* – to get it out in print that way… I am not only interested in how to get a message over but also commentary on the forms of cartoon representation that already exists around us.' (*Feminist Arts News*, 1980:3).

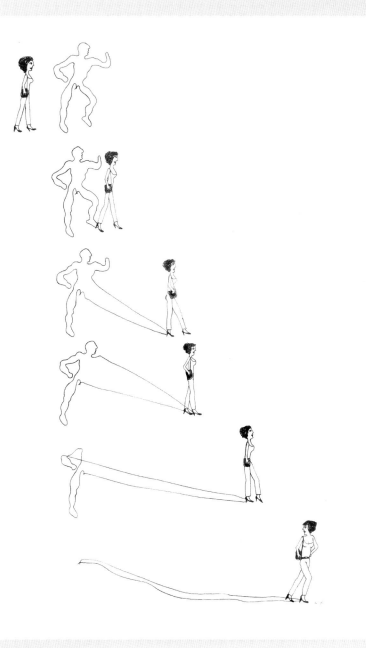

LEFT © Lesley Ruda, 'Man Made Fibre'. *Spare Rib*, c. 1977. 'This was a response to the pervasive verbal hassle by men on the street who seemed to think they could call you out about your tits or anything they felt like. I was also interested in the reduction of this male nuisance to a single line caught in a passing woman's high heel.'

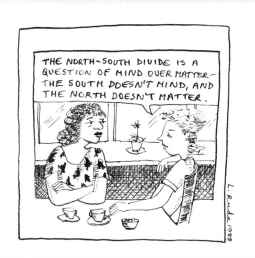

BOTTOM LEFT © Lesley Ruda, 'North-South Divide'. Sheba Feminist Press, 1989. Reprinted on Cath Tate Cards *Calendar*.

THE NORTH-SOUTH DIVIDE IS A QUESTION OF MIND OVER MATTER – THE SOUTH DOESN'T MIND, AND THE NORTH DOESN'T MATTER.

The expansion of feminist book publishing

Nicola Streeten

In 1979 four London-based women cartoonists, Christine Roche, Jo Nesbitt, Liz Mackie and Lesley Ruda, produced and self-published *Sourcream No. 1*. It was the first of a series of five British anthologies published between 1979 and 1984 and was unique as a series of British women's underground comics.

The women had met through the Women's Movement and were working for various publications, such as *Time Out* and *Spare Rib*. They considered approaching a publisher for the anthology, but decided they would have more freedom self-publishing. Christine Roche does not define the group as a collective but rather a group of cartoonists collecting their works together. They did not want to mix the work in the anthology, but divided the space available to publish their own contributions. Although they valued each other's opinions, there was no censure or democratic process over what they drew. It was a means

for them to visually express views they thought publishers may not publish.

An Dekke, a graphic designer friend of the group and a member of the *Hackney Flashers*, designed the anthology. The working practices of *Sourcream* were based on the idea of the collective transformed to absorb both the economic influences of the 1980s as well as to benefit from the supporting radical and feminist market structures that had become established. Following the publication of *No. 1*, a wider group of women became involved, responding to an advertisement placed in *Spare Rib*. From this, *Sourcream No. 2* was produced in 1981, published by Sheba Feminist Press in paperback.

BELOW Cover of *Sourcream No. 2*, reprinted by Sheba Feminist Press, 1983.

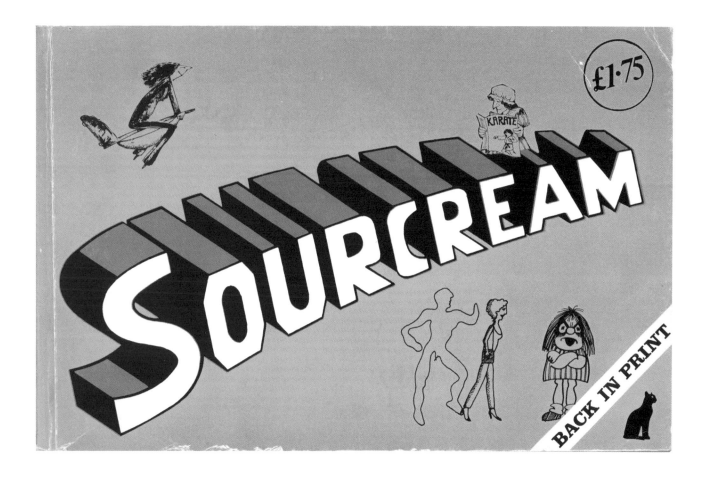

From the 1970s a number of feminist publishers were being formed, including Virago (1973), Onlywomen Press (1974), the Women's Press (1978), Kitchen Table Press (1980) Sheba Feminist Press (1980) and Pandora (1983).

As well as publishing prose they were providing a new outlet for the cartoons that were coming out of the women's movement. Cartoon collections were being published in books of work by a single person and anthologies of work by several women.

In 1983 the Women's Press decided to do a cartoon book as a response to the iconic year, 1984, that was approaching. Suzanne Perkins, the art director at Women's Press, and cartoonist Paula Youens threw out an invitation through the press and by word of mouth for women to send their hopes, fears and fantasies for 1984. As Suzanne Perkins wrote at the time:

'First a trickle, then a flood of parcels arrived. It was an amazing experience to open them all, to read the letter that came with some of them, and to see the variety of the drawings and ideas they expressed.'

Out of hundreds of submissions, Suzanne Perkins and Paula Youens chose the work of 66 artists, both by established well-known cartoonists and by amateurs submitting work for the first time. [1]

TOP © Marie-Helene Jeeves, 'Cake maker' 1984 from *Women Draw 1984*.

BOTTOM Cover of *Women Draw 1984*, Women's Press, 1983.

Janis Goodman

(1956–)

Janis Goodman's cartoons appeared in many publications such as *Everywoman* magazine and on postcards published by Leeds Postcards. She writes 'I am a Jill of all trades from architecture to animation via cartoons and illustration. I am now as far down the alphabet as 'e' for etching. I've not got further than 'f' for feminist and have no intention to do so!'

A contributor to *Sourcream*, Janis Goodman moved from London to Leeds in 1982 to work as part of the women's collective Leeds Animation Workshop (LAW), making animations about social issues. Other members were Stephanie Munro, Milena Dragic and Jane Bradshaw. They made over 30 animated films.

RIGHT © Janis Goodman, 'Iron, John'! 1992. Postcard published by Leeds Postcards. This was a response to *Iron John: A book about men* by Robert Bly – about the importance of men retaining their masculinity by hanging out in the woods with each other.

BELOW © Janis Goodman, 'Writers' top five audience questions', 2013. Produced for Ilkley Literature Festival.

WRITERS' TOP FIVE AUDIENCE QUESTIONS, PLUS...

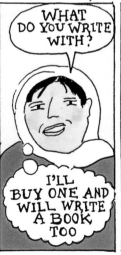
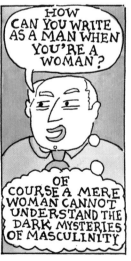
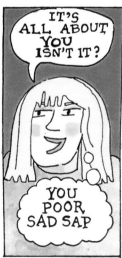

BY JANIS GOODMAN 2013

Fanny Tribble

(1949–)

'I discovered feminism in 1976 and started to do cartoons in those heady days of Women's Liberation Conferences. My cartoons were featured in *Spare Rib* and other publications. I had two books published, *Funny Trouble* (Sheba Feminist Press, 1982) and *Heavy Periods* (Grass Roots Books, 1979; Sheba Feminist Press,1983). I left England in 1985 for the greenness of Wales.'

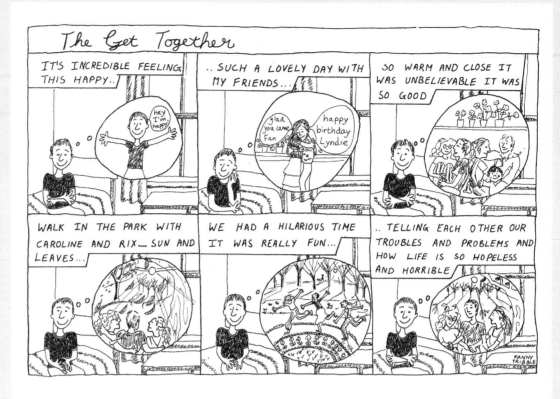

Fiona Scott

'I was a member of *Sourcream* comics and contributed to *Health Visitor* magazine and publications by many organisations including Shelter, Rights of Women and the trades unions. I have worked in mental health for the NHS for the last 25 years and recently returned to painting.'

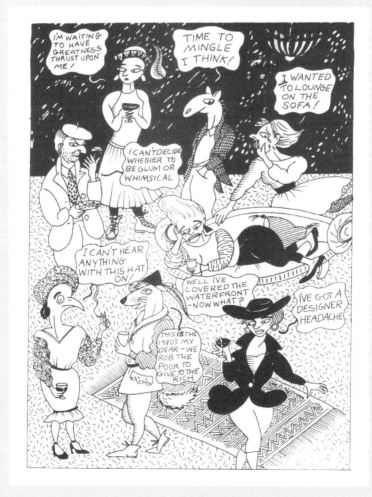

ABOVE © Fanny Tribble, 'The Get Together'. From *Heavy Periods*, Grass Roots Books, Manchester, 1979.

LEFT © Fiona Scott, 'Covered the Waterfront', 1987. Appeared in 1989 calendar, Cath Tate Cards.

Paula Youens

Formally trained in illustration at Exeter College of Art, Paula Youens's freelance career was with *The Times*, *The Guardian*, *The Observer* and many other national publications. Her cartoon collection *Lone Thoughts from a Broad* was published by The Women's Press in 1981. She co-edited *Women Draw 1984* with Suzanne Perkins. She is now an artist/printmaker exhibiting in galleries across the UK.

ABOVE © Paula Youens, 'Venus de Lino'. From *Lone Thoughts from a Broad*, The Women's Press, 1981.

LEFT © Paula Youens, 'Have a nice day'. From *Lone Thoughts from a Broad*, The Women's Press, 1981.

Annie Lawson
(1953–)

Annie Lawson developed a fan base from her numerous postcards, calendars and T-shirts sold on stalls in Camden Lock and Covent Garden markets and distributed around the country. Her work also appeared in several publications such as *Honey*, *The Guardian* and *Lush Times*. She has also had collections of her work published in books such as *Brilliant Advice!*, *More Brilliant Advice!* and *Life on the Hard Shoulder*. By the late 1980s and early 1990s, her characteristic stick figures had become a popular genre picked up by card companies and advertising campaigns. She now lives in Yorkshire and self-publishes zines.

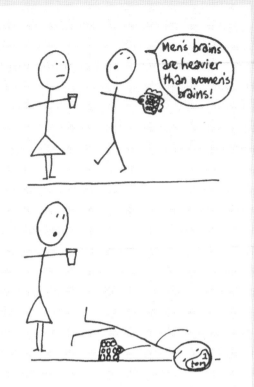

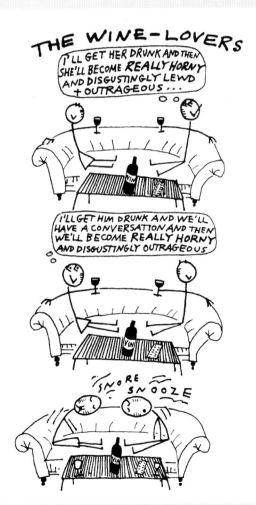

ABOVE LEFT © Annie Lawson, 'Imagine if I had children', 1988. Self-published postcard.

ABOVE RIGHT © Annie Lawson, 'Men's Brains', 1981. Self-published postcard. Later published in *Brilliant Advice*, Deirdre McDonald Books, 1988. 'Men's Brains was one of the first cartoons I did. I put it on my stall at Camden Lock as a self-published postcard, and this was the start of my cartooning career.'

BELOW LEFT © Annie Lawson, 'The Wine Lovers', 1996. Self-published postcard.

A resurgence of the postcard

Cath Tate

During the 1980s and 1990s, about 60 radical and feminist shops opened around Britain. These served a similar purpose to the WSPU, in providing outlets for feminist literature. In the 1980s, the postcard provided a perfect vehicle for feminist cartoons, as it had for women's suffrage in the early twentieth century.

I fell into producing postcards quite by chance. I was passionate about politics and shocked that so many people had voted for the ideas of Thatcherism in 1979.

I produced the photomontage 'Prevent Street Crime' in 1982 at an adult education evening class run by British artist Peter Kennard, whose photomontage work *Haywain with Cruise Missiles* (1980) was a much-publicised response to the siting of US missiles in Britain. I took my photomontage to the publicity department of the Labour Party. I was an active party member at the time, and thought they might be able to use it. I was told by their main designer that they didn't want to do any 'Thatcher-bashing stuff', so I looked to other ways of getting the image out.

Postcards, I discovered, were a cheap and simple way of getting political views out into a wider audience, as, unbeknownst to me, the Suffragettes had realised 75 years previously. I was not working in a vacuum, though. Annie Lawson was self-publishing cards to sell at London's Camden Lock market and Leeds Postcards, who first published Jacky Fleming's cartoons, was producing postcards for a range of political campaigns.

I started to produce political photomontage postcards in the early 1980s and distributed these through the network of alternative bookshops that could be found in almost every town across Britain; on stalls at political events, such as the Radical Bookfair organised by the Federation of Radical Booksellers; and the events put on by the Greater London Council (GLC) when Ken Livingstone was first mayor of London.

The alternative bookshops of the 1970s to 1990s set out to offer something slightly different from mainstream bookshops. They were centres where people could meet and campaigns could be organised in a pre-internet age. Apart from books, they also sold political postcards, badges, pamphlets, magazines, calendars and diaries, and jewellery made using women's and peace symbols. There was often a café attached selling vegetarian food of varying quality. Most of these bookshops offered a full range of feminist, lesbian and gay, socialist, environmental, green, anti-racist, anti-imperialist and anti-nuclear products which reflected the campaigns and ideas of the time and were often difficult to buy elsewhere. Sometimes these bookshops were the only places you could find, for example, the cartoon books of the *Sourcream* cartoonists or of Cath Jackson and Annie Lawson.[1]

Two or three days a week I visited these shops in, or within a day's drive of London. I would take a bag of samples, to sell postcards and then calendars and diaries, mugs, T-shirts and greetings cards. I had two small children but I was able to do this because at the time I had a partner who shared the childcare. Gradually, the business expanded, I moved more into the mainstream, and I was able to employ other people to help with the office and distribution work.

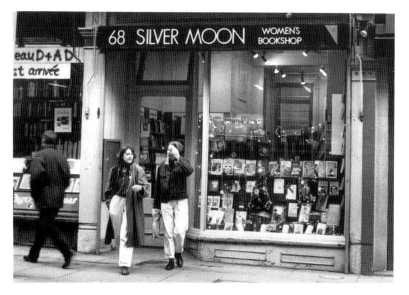

TOP © Pam Isherwood, published in *Spare Rib*. Opening of Sisterbite café in Sisterwrite bookshop, September 1979, with cartoonist Jo Nesbitt, left, who drew the benign looking nuns on the wall behind, and Brenda Whisker, right.

BELOW LEFT © Cath Tate, 'Prevent street crime' postcard, 1982.

BELOW RIGHT Front cover of *Radical Bookseller*, no.36, December 1984. Cath Tate and Peter Kennard on a stall at the Radical Bookfair.

Among the shops I sold to was Silver Moon, the women's bookshop on the Charing Cross Road. One of the women working there said she knew some other women cartoonists who wanted to publish their work and suggested I meet them. I was introduced to Kate Charlesworth, Viv Quillin and Cath Jackson. This was when the infamous Clause 28 of the Local Government Bill was going through Parliament. The clause stated that neither local authorities nor state schools could promote homosexuality. We were all angry about this, so I suggested we produce a set of six postcards to express what we felt and to help campaign against it. These postcards were sold by all the shops I was selling to at the time. I then gradually became aware that there was a wealth of women working as cartoonists and I began to expand the range of women cartoonists' work that I published.

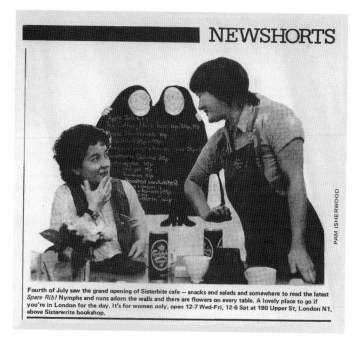

NEWSHORTS

Fourth of July saw the grand opening of Sisterbite cafe — snacks and salads and somewhere to read the latest *Spare Rib!* Nymphs and nuns adorn the walls and there are flowers on every table. A lovely place to go if you're in London for the day. It's for women only, open 12-7 Wed-Fri, 12-6 Sat at 190 Upper St, London N1, above Sisterwrite bookshop.

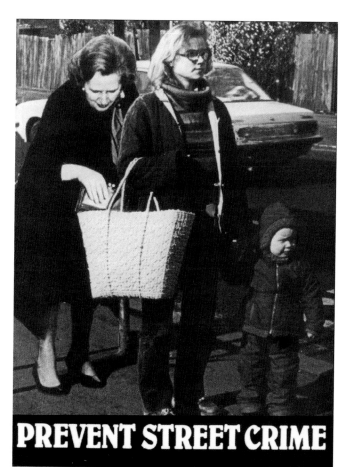

PREVENT STREET CRIME

THE RADICAL BOOKSELLER

number 36 december 1984

Books about the debt crisis
Socialist bookfair pictures
Trade news & the Xmas quiz

behind every gifted woman, there's often a rather talented cat

The postcard, 'Talented Cat', was probably the most successful one I produced at this time, selling hundreds of thousands over many years. The cartoonist Viv Quillin said she wanted to use humour to express feminist views because that was a way of getting them heard: a political tract would put people off. I also produced Christmas cards and calendars, which gave me the ability to use longer cartoons or small strips instead of only the simple spot cartoons, that are possible on postcards. In 1991 I started to collaborate with Carol Bennett of Knockabout Comics to produce the imprint FANNY to publish women comic creators.

I produced the bulk of the women cartoonists' cards and ephemera between the late 1980s and the late 1990s. I still produce cartoon cards but also other ranges of greetings cards that are now sold all over the world. Over the years I have learnt that humour, like beauty, is in the eye of the beholder. There is no one thing that everyone thinks is funny. What amuses you depends on your life experiences and where you are coming from. I produced funny cards by women cartoonists because no one else was doing so and they filled an unmet gap in the market.

it takes two heterosexuals to make a homosexual (in most cases)

TOP © Viv Quillin, 'Talented Cat', 1990. Postcard published by Cath Tate Cards. This was extremely popular and sold hundreds of thousands over many years.

BOTTOM © Viv Quillin, 'It takes two heterosexuals' postcard, 1988. Cath Tate Cards.

Viv Quillin
(1946–)

Viv Quillin began cartooning in the late 1960s and by the 1980s was earning an erratic income supporting herself and three children in a tiny terraced house by a gas works. Her cartoons have illustrated a wide range of publications from *New Internationalist* to *Parents* and have appeared on cards and other ephemera. Her books have included the bestselling *Opposite Sex* about women's sexuality. After training as a psychotherapist she divided her time between cartooning and seeing psychotherapy clients.

'I used humour as a wonderful way to express my angst at life's inequalities and to get concepts such as feminism across in a way that people could accept.'

In the 1970s, Quillin enrolled in a communications graphics course after having her applications turned down for two other courses – one because she 'wouldn't be able to keep up with the workload while looking after three children' and another because they didn't accept married women, on the grounds that they lacked commitment. (Viv had left her husband by this time!)

if God had intended women to think he'd have given them better jobs

© Quillin.

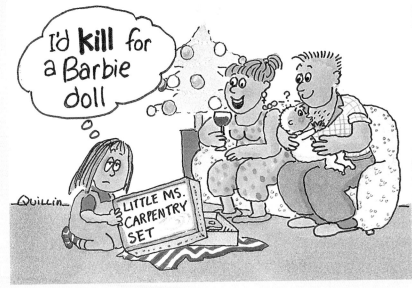

I'd **kill** for a Barbie doll

LITTLE MS. CARPENTRY SET

Quillin

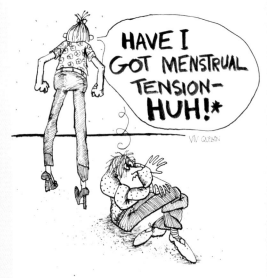

HAVE I GOT MENSTRUAL TENSION— HUH!*

VIV QUILLIN

LEFT © Viv Quillin, 'If God had intended'. Originally published in *Spare Rib* in black and white, then as a postcard.

MIDDLE © Viv Quillin, 'Kill for a Barbie doll', 1990s. Christmas card published by Cath Tate Cards. Mattel toys, the makers of Barbie dolls objected to this card and asked Cath Tate Cards to withdraw it.

BOTTOM © Viv Quillin, 'Menstrual Tension', 1981. From *Sourcream No. 2*. Sheba Feminist Press.

Cath Jackson
(1957–)

Cath Jackson is best known for her strip 'Vera the Visible Lesbian' which appeared in *City Limits* magazine in the early 1980s.

'At university, I discovered a whole new market for illustrations on leaflets, posters and university newspapers to make them look interesting. After university, I found the same was true for feminist, trade union and voluntary sector publications. If you worked for free, people were just glad to use your work. The paid work built from there.

'Initially I was inspired by an over-riding adolescent urge to communicate the futility of existence. Then, by social banality, and then, powerfully, by gay and lesbian politics, radical feminism and all-embracing humanitarian outrage.

'I abandoned my promising career as a cub journalist on *International Construction Magazine* to try to make a living as a cartoonist, thanks largely to a regular paying client, the *Nursing Times*, for whom I drew Nurse Nightshade. I worked full-time as a freelance cartoonist, in a studio with a bunch of designers over the Kwik-Fit garage in Crouch End. I shared a flat with my (absentee) landlady's cat.'

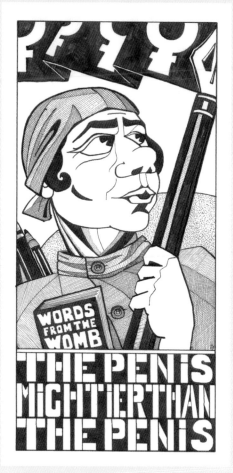

FAR LEFT © Cath Jackson, 'The Pen is Mightier than the Penis', *New Statesman,* mid-1980s. Postcard, Cath Tate Cards, 1990s.

LEFT © Cath Jackson, '40 million Bigots' postcard, 1988. Cath Tate Cards.

MIDDLE © Cath Jackson, 'The Joy of Lesbian Sex', 1984. *City Limits.* 'This is one of the bi-monthly Vera the Visible Lesbian strips I drew for *City Limits* in the early 1980s. It's based on Sisterwrite, the women's bookshop in Upper Street, Islington.' Unlike male homosexuality, lesbianism has never been illegal in the UK. However, lesbians have until fairly recently lived below the radar. Jackson's 1980s strip celebrated the fact that many now felt the confidence to be visible. A collection of Vera strips were reprinted by The Women's Press in 1987.

BOTTOM ©Cath Jackson, 'The Community Midwife'. Cartoon produced for 'Nurse Nightshade' strip. Nursing Times Publications, 1984.

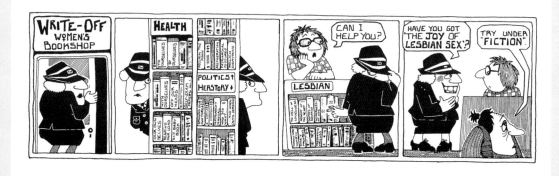

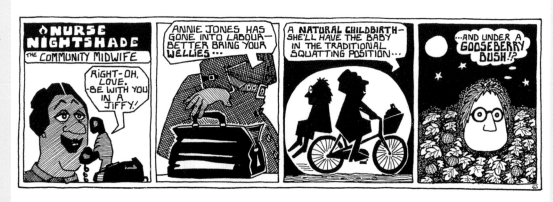

Kate Charlesworth

(1950 –)

Kate Charlesworth was born in Barnsley and studied graphics at Manchester College of Art and Design. Her extensive output includes strips and cartoons for *The Guardian*, *The Pink Paper*, *The Independent*, *New Scientist* and *DIVA*. She illustrated *Sally Heathcote, Suffragette* (Jonathan Cape, 2014), contributed to *Nelson* (Blank Slate, 2011) and is currently working on her memoir, *(A Girl's Guide to) Sensible Footwear* (Myriad Editions, 2019).

'In the mid-1980s, I was asked to do some illustration by an ad agency running a campaign for British Gas. The idea was to show an old geezer in a strip club where the show had had to be called off because the strippers were cold (they were not using British Gas!). It was the only time I have turned a job down and I gave them a real rant about sexism. They were rather surprised and said "yes, it was bad that the men didn't get what they wanted at home", which was rather missing the point.'

TOP © Kate Charlesworth, *(A Girl's Guide to) Sensible Footwear*, Myriad Editions, 2019. The book combines autobiography with a history of LGBT experience since 1950. The book's title is used as code within the lesbian community as in 'Mary wears sensible footwear. You should invite her to the party'.

BELOW © Kate Charlesworth, 'Plain Tales from the Bars' strip, *The Pink Paper*, 1988.

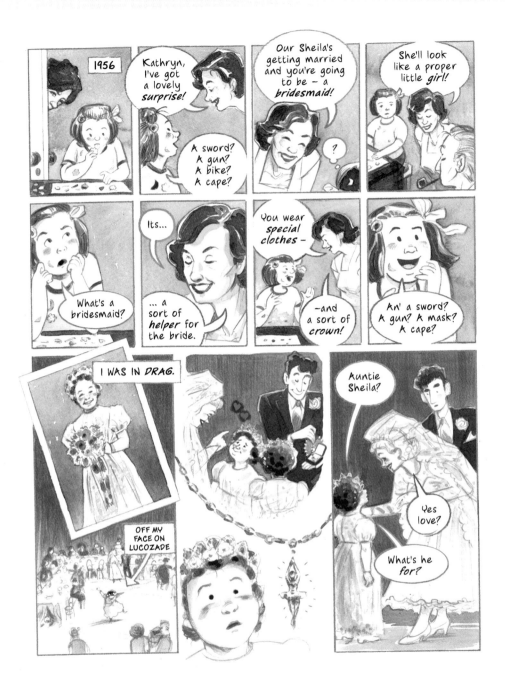

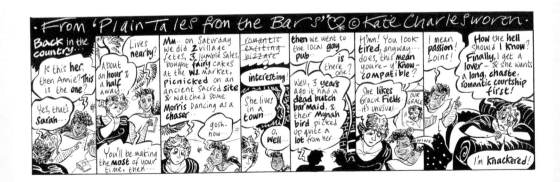

Grizelda

Grizelda has been a professional cartoonist for over 20 years. She won the Cartoon Art Trust 'Joke Cartoonist Of The Year' Award in 2008. Her cartoons have appeared in *The Times*, *Sunday Times*, *TES*, the *Big Issue*, the *New Statesman*, *Private Eye*, *The Oldie*, *The Spectator*, *Prospect* and *The Independent*. She lives in the UK, by the sea.

'I am very fortunate to be doing a job I love that doesn't involve lifting things or standing around being nice to members of the public. I have no examples of gender disparity from my time cartooning. This could have something to do with the fact that I still receive emails etc from people assuming I am male. So many cartoonists are male, even the ones called Mary, Charlotte and Grizelda.'

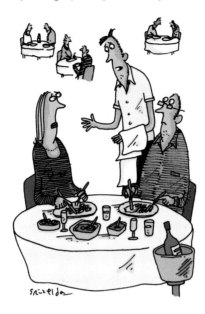

"Is everything OK? You haven't photographed your food yet."

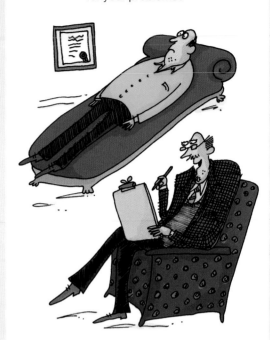

"Have you considered blaming immigration for your problems?"

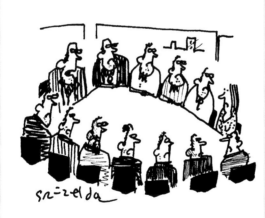

"Well, you're the only one who thinks we're a sexist organisation."

TOP LEFT © Grizelda, 'Is everything OK? You haven't photographed your food yet', *The Spectator*.

TOP RIGHT © Grizelda, 'Have you considered blaming immigration for your problems?', *The Spectator*, 2015.

ABOVE LEFT © Grizelda, 'Sexist organisation', *Private Eye*, issue 1367. Reproduced with kind permission of *Private Eye* magazine / Grizelda.

ABOVE RIGHT © Grizelda. A photograph of some of Grizelda's notebooks showing the profusion of ideas she jots down every day.

Maggie Ling
(1948–)

A fashion designer, illustrator, children's book illustrator and cartoonist, Maggie Ling's cartoons have appeared in books, magazines and newspapers, including *The Guardian*, *The Observer* and the *New Statesman*. A collection of her cartoons, *One Woman's Eye*, was published by Virgin Books in 1986. She is now a short story writer.

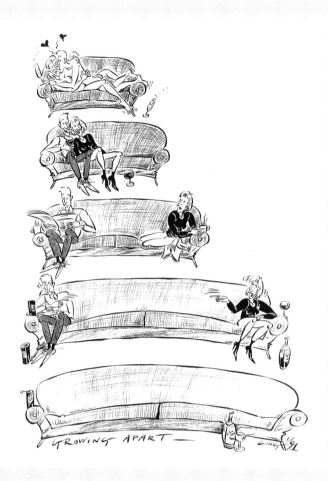

LEFT © Maggie Ling, 'Growing Apart', 1991. 'It was exhibited in an exhibition in Croatia and published in the anthology *Ljubav… stol & krevetin* – a catchy little title, which I have translated as: *Love… table and bed* that followed in 1994.'

BELOW © Snowy Lake, 'Stop making excuses, Joanna – just get yourself into that bath', c. 1990.

Snowy Lake
aka Helen Cusak
(1952–)

'I consider myself both a socialist and a feminist, but primarily a humourist. My work has been published in *7 Days* newspaper, *Sourcream*, *Spare Rib* and *Cosmopolitan*.' A collection of cartoons, *Rocking the Boat*, was published in 1989 by Futura.

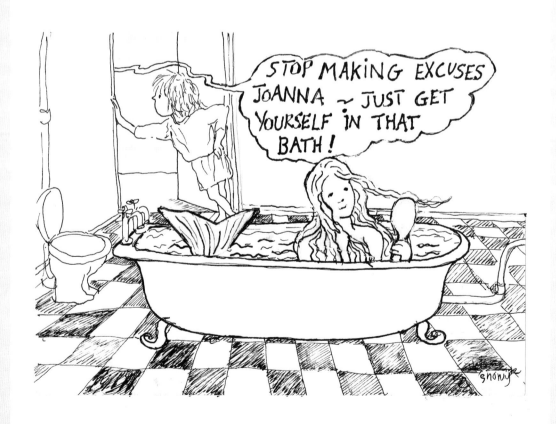

Sophie Grillet
(1954–)

Sophie Grillet studied illustration, then physics, at university. In the 1980s, her cartoons appeared in a number of British publications including *The Guardian*, *The Observer* and the *Evening Standard*, and on Cath Tate Cards. She co-authored *Socialism for Beginners* (Writers and Readers, 1986).

She moved to the USA in 1996, completed a cartoon book, *Feminism for Teenagers* and took a child-rearing break.

She began painting in 2009 and is now an artist working in Ann Arbor, Michigan, experimenting with a variety of media including aluminium, paint, metal, clay and yarn. She co-owned a gallery from 2013 until 2015.

Caroline Holden
(1954–)

Caroline Holden started drawing cartoons while working at Mel Calman's gallery, The Workshop, which later became The Cartoon Gallery.

She continued working on children's books, illustrating the original Adrian Mole books for Sue Townsend, and cartooning for *Private Eye*.

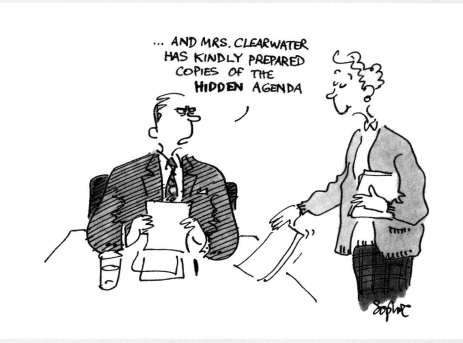

ABOVE © Sophie Grillet, 'The Hidden Agenda', 1990s.

LEFT © Caroline Holden, God putting the cat out, *Danger God Working Overhead*, Mandarin, 1985. 'I sent an invitation to The Archbishop of Canterbury inviting him to the launch and received a lovely reply from Terry Waite.'

God putting the cat out . . .

Zines and DIY meet cartoons and comics

Nicola Streeten

A number of significant British activist-led zine-style alternative feminist publishing projects appeared during the early 1990s which included cartoons and comics. These included *Shocking Pink I, II* and *III, Bad Attitude, Subversive Sister, Harpies and Quines*. The titles originated from a 'Riot grrrl' ethos – responding to political issues at the time through a feminist lens via comics. For Erica Smith, graphic designer and illustrator, the starting point was to create a publication by and for women cartoonists and comic artists that addressed feminist issues.

BELOW © Erica Smith, *GirlFrenzy* covers (artwork No.1 © Suzy Varty; Nos.3, 4, 5 © Erica Smith; No.2 © Caroline della Porta; No.6 © Caroline Risdale).

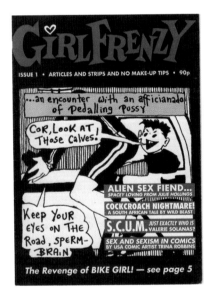
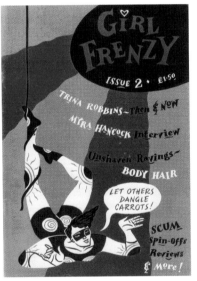
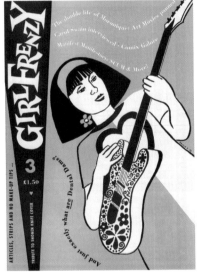

Erica Smith

(1963–)

Erica Smith grew up on *Twinkle*, then *The Beano*, then *Jackie*. In 1991 Smith discovered the Hernandez Brothers' *Love & Rockets* and this revitalised her interest in comic strips. In 1991 she created and edited *GirlFrenzy*, a women-only anthology of 'Articles, Strips, and No Make-Up Tips'. There were six issues produced between 1991 and 1997, with *The GirlFrenzy Millennial* published in 1998.

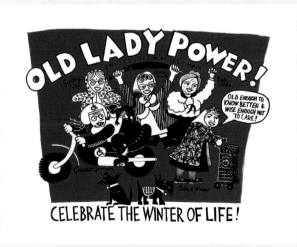

ABOVE © Erica Smith, 'Neither Bloody Nor Bowed'. Published in *The GirlFrenzy Millennial*, edited by Erica Smith, 1998.

LEFT © Erica Smith, 'Old Lady Power', Glasgow Women's Library calendar, 1998.

Rachael House

(1961–)

Rachael House makes events, objects, drawings and performances. In the 1990s she was part of the thriving UK queerzine scene with her autobiographical *Red Hanky Panky* (1993). She has facilitated political zine making at various venues including for The Feminist Library at the Tate Modern. Her work has been exhibited at numerous galleries and institutions.

'I started my autobiographical comics zine *Red Hanky Panky* in 1993. There was a flourishing queerzine scene in the UK and internationally, and my zine had an emphasis on bisexuality. Remember – these were historical times, far from the LGBTQIA+ inclusiveness we have today.'

ABOVE © Rachael House, page from *Zine Tips*, created for the Feminist Library's Tate Late event in February 2017, later printed by Footprint Workers Co-Op.

BELOW © Rachael House, 'Untitled pages 1 and 2', 2009. A response to a request from Patrick Staff and Ed Webb-Ingall to contribute to *Seripop* fanzine, accompanying the Baltic Centre For Contemporary Art event of the same name, curated by Sophie Brown.

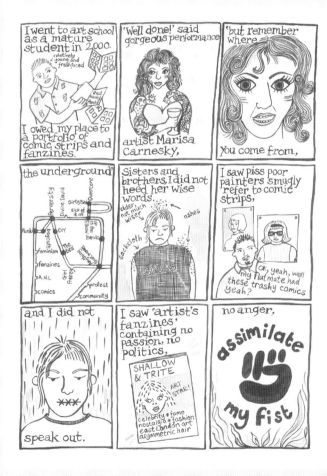

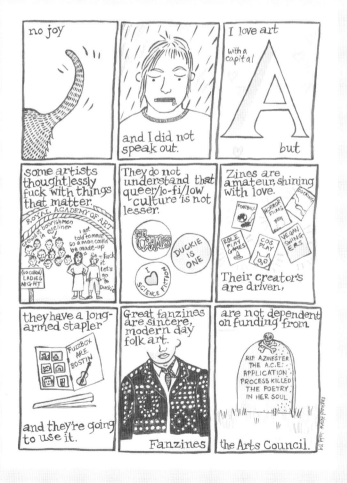

FANNY and
The Directory of Women Comic Strip Artists, Writers and Cartoonists

Carol Bennett

The increase in the number of women cartoonists in Britain enabled Carol Bennett of Knockabout Comics to collaborate with Cath Tate to generate a series of British women's comics and cartoon anthologies. Launched in 1991, *FANNY* became their flagship title.

I had been co-running the publishing company Knockabout Comics with my then spouse Tony Bennett since about 1980. We had published comics by notorious alternative artists such as Gilbert Shelton (*The Fabulously Furry Freak Brothers*, 1971–97; 'Fat Freddy's Cat') and Robert Crumb ('Mr Natural' and 'Fritz the Cat'). These and others were imported mainly from California. Because they included alternative lifestyle and drug awareness subject matter, the company was brought to the attention of HM Customs and Excise resulting in seizures under the ancient laws of Public Order and Obscenity.

We had a stall at the regularly held UK Comic Art Convention (UKCAC) and artists would leave examples of their work plus details. When the piles of artwork and addresses had grown out of all proportion we created a database (hand-written card files) from which we would extract names when asked for by other publishers. There was of course no internet and we relied on the postal system. Some of the artists who approached us were women. Eventually I separated the women artists to make the selection easier. As an increasing number of enquiries and notifications of events for women began coming my way, I decided to create a newsletter – the 'FANNY Directory' – because it was easier than communicating individually.

In 1990 I had edited *Seven Ages of Women* (Knockabout 1990)[1] and I was interested in developing the publishing of women's work to redress the gender balance. In 1990 I met Cath Tate. Between us, we had the ability and access to talent to create our own comic. The *FANNY* anthologies were a result of my knowledge of the comics world and Cath's knowledge of women cartoonists.

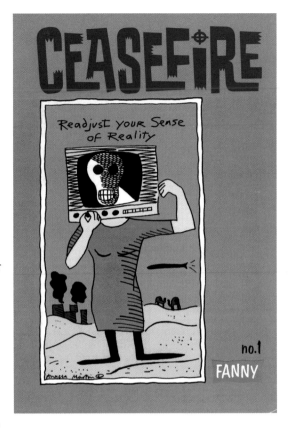

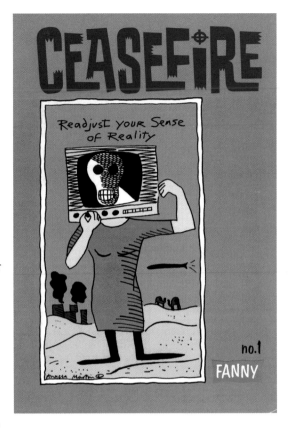

ABOVE © Angela Martin. Front cover illustration for *FANNY* no. 1 'Ceasefire', 1991.

In 1991, as the First Gulf War blasted away the remains of the years of love and flowers, Cath, myself and the women of the Directory produced the first *FANNY* anthology, 'Ceasefire'. Cath and I edited it – it was published by Knockabout with support from Cath's company – and included contributions from 20 women cartoonists.[2] Printed in Canada, it entered the country on the very day of the attack on Kuwait. Customs officers stopped its importation. The title, they decided, promoted war. Several hours of talking finally convinced them it was a women's perspective on war and they released the comics. It was a different era, and it was surprising to the powers that be that women could publish comics. Two thousand copies were printed and distributed to comics shops, mainly through Knockabout's networks.

FANNY no. 2 was published in 1991. The title was 'Voyeuse: Women View Sex' and it was themed around sexual relationships. It was edited by Cath and myself and published by Cath Tate Cards. Some of the contributors were the same as featured in 'Ceasefire', and others were introduced.[3]

I published and edited *FANNY* no. 3 – 'Immaculate Deception: Dissenting Women' in 1992. I received funding from the London Arts Board to produce the issue and it included contributions from 15

women. [4] In 1993 and 1994 I edited *Dykes' Delight* no.1 published as a FANNY imprint by Knockabout Comics. These anthologies showcased work by lesbian cartoonists, and Kate Charlesworth was instrumental in leading the collection and collation of works. For this publication I received public funding from England's Foundation for Sport and the Arts, and eight women cartoonists contributed. [5] The anthologies included contributions from a total of around around 55 British women cartoonists.

'The Breakfast Project' (1992) was an exhibition idea themed around famous women having breakfast. I intended this as the start of a whole series, but by the early 2000s, comics and books had moved online with women producing their own work in blogs and websites.

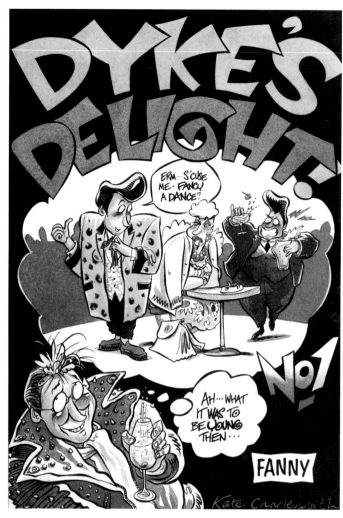

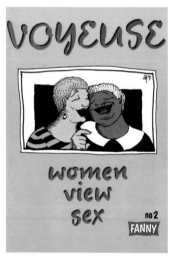

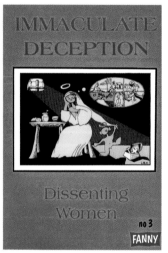

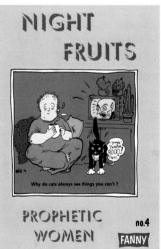

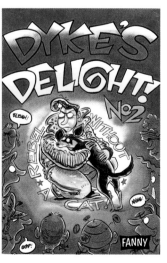

TOP © Kate Charlesworth. Front cover of *Dykes' Delight* No. 1, 1993. Carol Bennett. The first in the radical lesbian comic series, *Dyke's Delight* appeared with this stylish cover by Kate Charlesworth, featuring her character 'Auntie Studs'

FAR LEFT CLOCKWISE Front cover of *FANNY* no. 2 'Voyeuse', 1991; front cover of *FANNY* no. 3 'Immaculate Deception', 1992; front cover of *Dykes' Delight* no. 2, 1994, illustration © Kate Charlesworth; front cover of *FANNY* no. 4 'Night Fruits', 1991, illustration © Lee Kennedy. Published by Carol Bennett, 1991–1994.

BOTTOM Photograph: Angela Martin's front cover illustration for *FANNY* no. 1 'Ceasefire', 1991, was the first image displayed as visitors entered the biggest exhibition of comics in the UK – Comics Unmasked, at the British Library in 2014.

Angela Bailey

Angela Bailey worked as an animator and film designer, writing and drawing comic strips and political cartoons in her free time. Her contribution to 'The Breakfast Project' centred on the fashion doll Barbie, who represents everything artificially female.

Julie Hollings

Julie Hollings contributed to a number of women's comics including the American publications *Tits & Clits Comix* and *Wimmen's Comix*. Her stories appeared in *Outrageous Tales from the Old Testament* (Knockabout Comics, 1987), *Seven Ages of Women* (Knockabout Comics, 1990) and the *FANNY* anthologies. She was one of a few women to work for *2000AD*, drawing the series 'Dire Streets'.

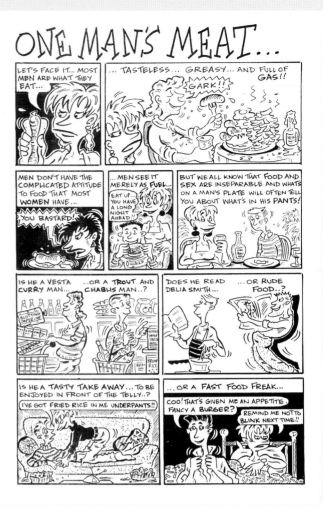

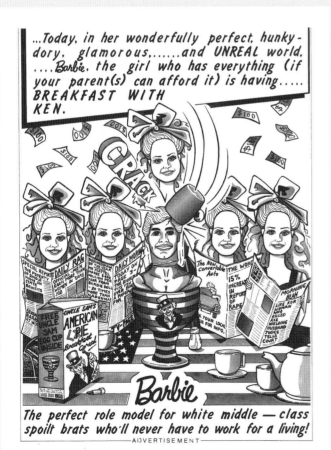

LEFT © Angela Bailey, 'Barbie The Girl Who Has Everything', 'The Breakfast Project', Carol Bennett, 1992.

ABOVE © Julie Hollings, 'One Man's Meat', *FANNY* No. 2 'Voyeuse', 1991.

Jackie Smith
aka Jackie Prachek
(1959–)

Jackie Smith (Prachek) began creating comics in the 1980s 'because it made sense'. She worked for a variety of companies and magazines, most notably for Knockabout and created the strip 'PC Chainsaw' for the magazine *Back Street Heroes*. She exhibited at the international comics festival in Angoulême in 1992 and is still drawing comics, illustrating and painting.

'All those comic conventions were a bit weird; so much leather, so much patchouli, so many pony tails, so many men. I do remember one bloke asking me if I was here to make the tea and another time being asked into a male editor's office so he could check me out.

'I approached *Back Street Heroes* with the PC Chainsaw strips after initially sending them to *Viz* who sent me a nice letter back suggesting I send them to *Women's Own*. *Back Street Heroes* was a biker magazine and had quite a liberal approach to their content. I wrote and drew the strips and got paid £45 for the panels.'

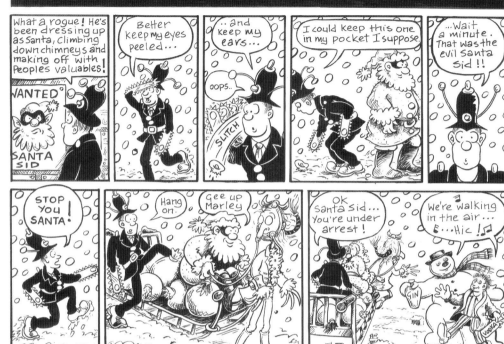

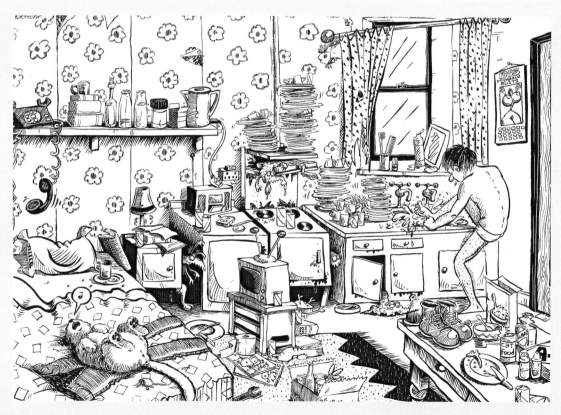

Top © Jackie Smith, top two rows from 'PC Chainsaw's Christmas Adventure', *Back Street Heroes*, 1990.

BOTTOM © Jackie Smith, 'The Bachelor'.

Caroline della Porta

(1959–)

Caroline della Porta's work was featured in publications throughout the 1980s and 1990s, including *Deadline*, *Crisis*, *Revolver*, *GirlFrenzy*, the anthologies *First Love*, *The 7 Ages of Women* and *The Worm: the world's longest cartoon strip*. She illustrated *Whisker the Kiwi Chick* (BigWords-Books, New Zealand, 2016).

'Thankfully my work was commissioned by right-minded publishers like The Women's Press and Knockabout. I didn't experience as much gender disparity as I did class disparity.

'I still cartoon – although I prefer the term "graphic narration".'

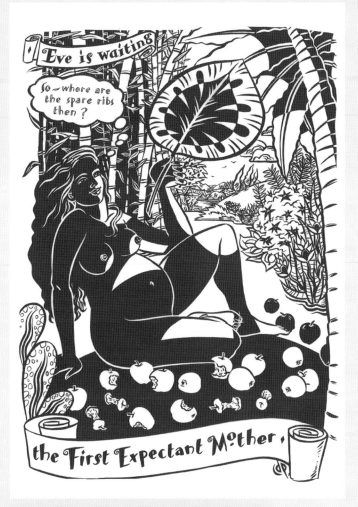

Lucy Byatt

(1959–)

Lucy Byatt was first published in *Spare Rib* in 1979. She worked with the *Sourcream* Collective in the 1980s and was published by FANNY in *Dykes' Delight* (1 and 2) and *Women Out of Line* in the 1990s.

'I found American feminist/lesbian comics in the '70s and was immediately fascinated by the politics and drama that they produced. Lesbian political love stories didn't seem to be the kind of things 14-year-old boys at comic conventions would be interested in.'

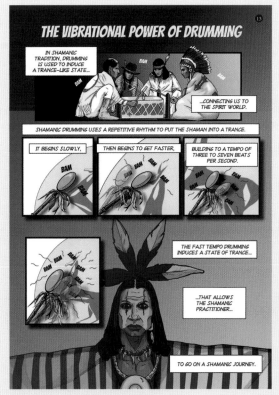

Lee Kennedy

New York-born Lee Kennedy has been doodling and scribbling comics for 65 years or so, and publishing them since the late 1980s. She deals mostly with grim autobiography and urban vignettes. Dreams, Catholic school, and day-job horrors also feature heavily. She has been included in many exhibitions and comic anthologies, and collections of her artwork are now available from FactorFiction Press. Her regular doodles and 'ventings' still appear on Facebook.

Kennedy says that her cartoons and comics are often inspired by incidents she observes, or things she has overheard.

ABOVE © Lee Kennedy, 'On the Bus', *Wage Slave*, 2002.

Corinne Pearlman
(1949–)

Corinne Pearlman's first cartoons appeared in *The Leveller* in 1976, and her first strip in the *The Optimist* in 1977. She has co-edited and contributed to comics anthologies, including *The Comic Book of First Love* (Virago, 1988) and *The Comic Book of Facts of Life* (Fantail, 1991).

She drew a series of strips, 'Playing the Jewish Card', exploring her role as a 'non-Jewish Jew', which appeared in the UK's *Jewish Quarterly* between 2002 and 2011.

As Creative Director at Myriad Editions, Corinne Pearlman commissions the list of graphic novels and oversees the First Graphic Novel competition. She is also a coordinator of Sussex cartoonists' network Cartoon County, and was a founding partner of Comic Company in the 1980s.

'Comic Company developed into a partnership producing comics-illustrated health information. Myriad's special interest in graphic medicine was influenced by my background in Comic Company.'

LEFT © Corinne Pearlman, 'The Passion', *The Comic Book of First Love*. Virago, 1988.

ABOVE © Corinne Pearlman. Front cover of *4GIRLS*, produced by Comic Company for the Family Planning Association, 1992–2017.

BELOW © Corinne Pearlman. Detail from 'Playing the Jewish Card: The Gap Year', *Jewish Quarterly*, Number 194, Summer 2004.

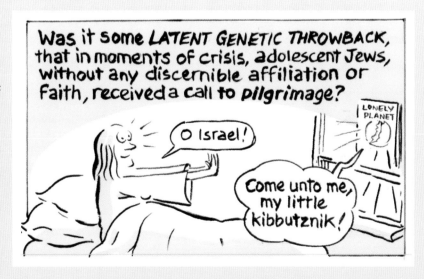

Cinders McLeod

(1960–)

'All my cartoons were political; all of them were long-running newspaper cartoons, and all except 'Word of the Week' were pocket cartoons. 'Word of the Week', written by the brilliant Edinburgh etymologist, Betty Kirkpatrick, and illustrated by me was (as far as I know) the only writer/cartoonist two-woman team at that point in the history of newspapers. We so rocked!'

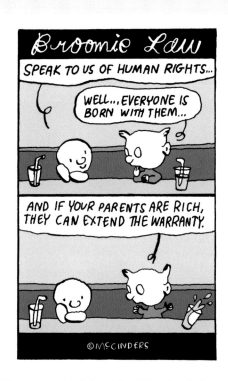

Myra Hancock

now Myra Mannering

'Once, at a comic event in Coventry, I sat with two fellow writers from *2000AD*, both male. I eventually entered their conversation on the topic of comics, revealing myself to be informed and involved. "So WHO are you?" the others said. "We thought you were just a girlfriend." When I explained I wrote "Tao de Moto" (her own series in *2000AD*, illustrated by David Hine) they looked somewhat embarrassed.'

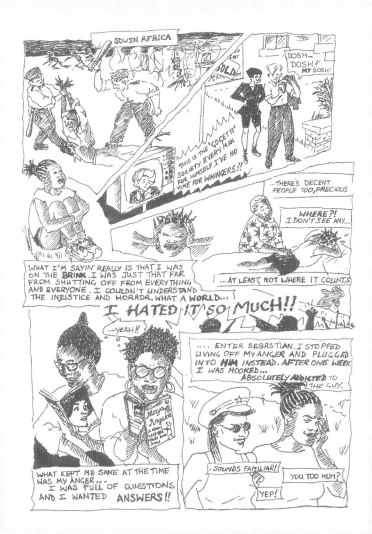

ABOVE LEFT © Cinders McLeod, 'Broomie Law: Speak to us of Human Rights', *The Herald*, Glasgow, 6 December 1999. McLeod says of her weekly pocket cartoon: 'What I wanted "Broomie Law" to be was a voice of the people'.

ABOVE RIGHT © Cinders McLeod, 'Sod the Public: (n) Customer (v) To Cuss', *Scotland on Sunday*, 15 January 1995. McLeod collaborated with columnist Sally Kinnes on a consumer rights column called 'Sod the Public (Something Ought To Be Done)'.

LEFT © Myra Hancock, 'A Walk on the Wild Side', *The Comic Book of First Love*, edited by Corinne Pearlman and Philip Boys, Virago, 1988. 'It contains a character, Miss March, who I invented as an agony aunt to sort everyone out: including me. She was tall, slim and wise and had an angular face which I always wanted. I had a weekly strip in *City Limits* around this time with her in it: an illustrated rhyming advice column.'

The Hand Drawn in a Digital Age

Nicola Streeten

The internet has enabled rapid information exchange and created a platform that has nurtured virtual communities and reinforced physical ones.

The dawning of the new century saw works by women cartoonists and comics artists more confidently positioned in mainstream British culture. Feminism had also become mainstream, with greater social and political power for women. The continuing feminist presence and influence, particularly within publishing and academia, has played an important role in increasing the visibility of women cartoonists and comics artists, together with a generation of young women redefining what feminism and cartoons and comics can be. This has been assisted by the expansion of the internet, which has offered new opportunities for expression and debate.

The internet has enabled rapid information exchange and created a platform that has nurtured virtual communities and reinforced physical ones. Activity that began before 2000 has accelerated, with a growing emphasis on the comics community and the social aspects in the mode of production of cartoons and comics. The circulation of small-press works produced by individuals and collectives has been supported by the internet, which has facilitated selling through online shops, such as Etsy, and providing showcases through sites such as Tumblr and Instagram.

The digital age has also invited innovative experimentation such as the annual Webcomic Artist Swap Project (WASP), initiated by Richy K. Chandler in 2016.

In addition, blogs have provided an opportunity for women to write about and review comics in ways that challenge the status quo. Writer and journalist Zainab Akhtar set up her blog Comicsandcola in 2011. Her remit has been global and she contributes a significant voice to the British comics community. Akhtar demands that the inadequate representation of people of colour in comics is addressed. As this book testifies, the history of women's cartooning is understood within a framework of whiteness. However, the snapshot of current activity in Britain included in these pages, of which Akhtar is part, celebrates a growing embrace of intersectional feminism.

Anthologies have continued to offer another successful platform for publishing new work. In 2001, Selina Lock, a comics writer, co-founded the small publishing press Factor Fiction and in 2008, she edited the first in a series of anthologies, *The Girly Comic Book 1*, 'with no other guiding principle than having every strip feature a female lead'. The decision not to restrict the comic to work by women was because most submissions were from men. She therefore aimed to produce what she describes as a 'girl-centered, girl-positive comic written and illustrated by anyone'. With a wide variety of topics and styles, the series included works by established cartoonists from the small-press, such as Lee Kennedy, Jeremy Day and Jenny Linn-Cole. At the same time, the anthologies introduced works by many younger artists such as Kate Brown, Asia Alfasi, Karen Rubins, Karrie Fransman and Laura Howell. The series ran until 2011. A more recent example is *Comic Book Slumber Party*, founded by Hannah Chapman in 2012 and joined by Alice Urbino in 2015. These anthologies have showcased comics from female-identifying, non-binary, and trans creators. Their mission is to tell stories 'as bad ass as they are!'

Jeremy Day
(1971–)

Jeremy Day, also known as Jeremy Dennis or 'Cleanskies', was instrumental as an editor, writer-artist and convention organiser in the burgeoning small-press scene in the UK in the 1990s and 2000s. In 1992 she co-founded Caption, a British small-press comics convention in Oxford, with Adrian Cox, Damian Cugley and Jenni Scott. Day produced a number of self-published comics, contributed to *GirlFrenzy* (1991–1998) and later *The Girlie Comic* (2001). She lives by the philosophy that anyone can make comics, and everybody should.

'I did not consider my comics as an earning route. My motivations were DIY, anti-establishment, and anti-restriction, with a particular focus on gender, sexual identity and sexuality restrictions. Appropriating privilege was an important part of what we did, and invading professional, establishment space, seizing the means of production and circumventing, subverting or ignoring the constructed comics professional world and the toxic concepts of talent and canon were absolutely key. Freesheets, festivals and fun were our tools.'

In 2003, Day co-founded the *Whores of Mensa* comics anthology with cartoonists Sasha Mardou, Lucy Sweet and later Ellen Lindner.

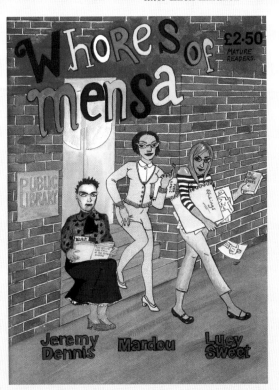

There was a time

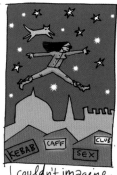
I couldn't imagine

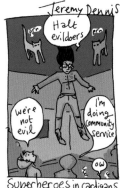
Superheroes in cardigans

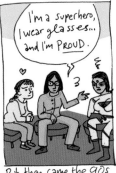
But then came the 90s

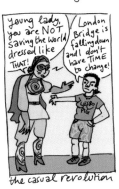
the casual revolution

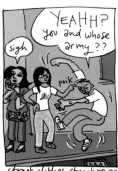
street clothes, street powers

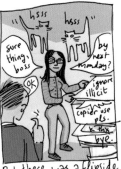
But there was a flipside

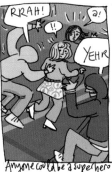
Anyone could be a superhero

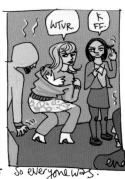
So everyone was.

ABOVE © Jeremy Day, 'Appliqué Everything', *The Weekly Strip*, 6 October 2008. '*The Weekly Strip* was my way of finding the positive levers in the world around me and twisting them into a better life.'

LEFT © Lucy Sweet, Mardou and Jeremy Day, cover for *Whores of Mensa* Issue 1, edited by Mardou, 2004. The founders said they wanted to create 'something that was a long way from the regular crush-them-in underground comic with its long contributor list, short story length and quick and dirty strips'.

Ellen Lindner
(1978–)

In 2011, while based in Britain, American cartoonist and illustrator Ellen Lindner took over editorship of the *Whores of Mensa* anthology under the new name *The Strumpet*. Contributors to both anthologies included Sally-Anne Hickman, Cliodhna Lyons, Francesca Cassavetti, Patrice Aggs, Sarah McIntyre, Kripa Joshi, Tanya Meditzky, Hannah Berry, Julia Scheele and Sofia Niazi.

Lindner is author of *Undertow* (Soaring Penguin Press, 2012), a graphic novel about a girl suddenly overwhelmed by events beyond her control: her mother's alcoholism, her best friend's death. She is also author of Ignatz-nominated comic series *The Black Feather Falls* (Soaring Penguin Press, 2016.

BELOW LEFT © Ellen Lindner, cover for *The Strumpet* Issue 1 'The Dress Up Issue', edited by Jeremy Day and Ellen Lindner, 2011.

BELOW RIGHT © Jeremy Day, cover for *The Strumpet* Issue 2 'Going Places', edited by Jeremy Day and Ellen Lindner, 2012.

BOTTOM © Ellen Lindner, *Undertow*, Soaring Penguin Press, page 5, 2012. Brush, pen and ink with digital colour and textures.

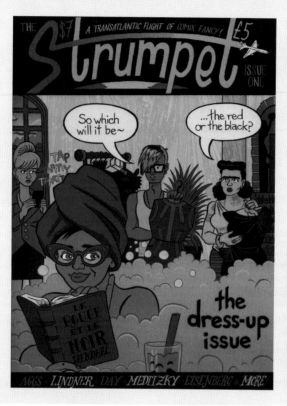

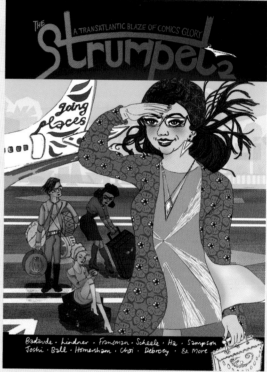

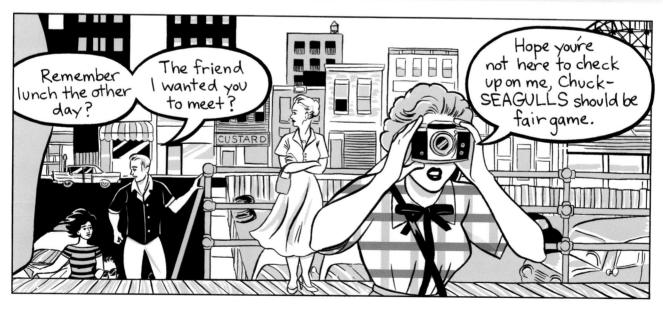

Lucy Sweet
(1972–)

The writer and cartoonist Lucy Sweet is based in Glasgow. She is the author of the feminist fanzine (and subsequent comic anthology) *Unskinny* (1997). Her cartoons have appeared in *The Independent* and *The Big Issue*, and in many female-led small-press publications, such as *GirlFrenzy*, *The Strumpet*, *Whores of Mensa* and *Team Girl Comic*.

'I didn't cartoon for a long time. It was to do with time constraints and needing to make money. With journalism I could turn something around quickly and get paid… I returned to it with *Whores of Mensa* and *The Strumpet*, and later with *Team Girl Comic* in Glasgow, but these were single stories.'

BELOW © Lucy Sweet, 'Passion for Fashion', *The Strumpet*, 'The Dress-up' Issue, 2011.

Patrice Aggs
(1978–)

Patrice Aggs has illustrated countless children's books and written a few, but her primary passion is comics. As an ex-pat American, her influences are closer to US newspaper strips than the British *Beano*-style. Her current projects include graphic short stories for both kids and adults, and science comics for academic publishers.

'An editor at Random House once told me I'd never get away with doing a book with a speech balloon on the cover. It just made me determined to shove speech balloons on EVERYTHING from then on.'

BELOW © Patrice Aggs, 'The Three Graces', *The Strumpet*, 'The Dress-up Issue', 2011. '"The Three Graces" was a response to someone I'd just met. I needed to do a comic about a ballsy woman bursting with energy – someone who genuinely didn't give a f**k.'

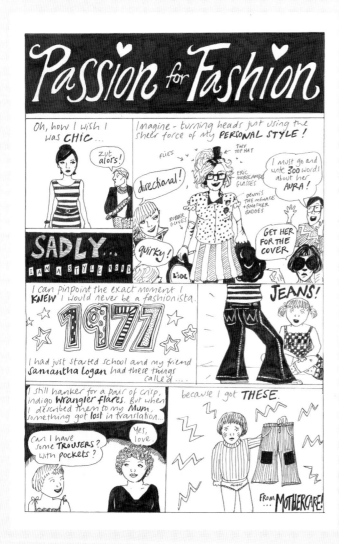

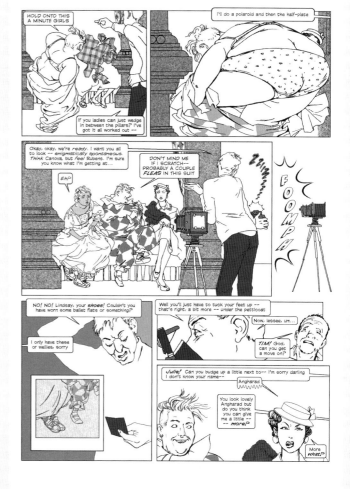

Kripa Joshi

(1978–)

Kripa Joshi is the creator of Miss Moti, a plump character who frequently blurs the line between fantasy and reality.

Kripa Joshi studied at the School of Visual Arts, New York, with a Fulbright scholarship. Her work has been featured at the House of Illustration, London Transport Museum and the Lightbox.

'This comic was a part of the anthology *Shattered*, a follow up collection to *Secret Identities*, which aimed to create superhero stories with Asians as protagonists instead of just sidekicks or villains. The theme given to me was Alien. I took inspiration from how, in America, immigrants are referred to as 'aliens'. This comic also came from my experience of being scrutinised as an Asian person living in the West.'

She is currently working on the 'Miss Motivation' series, which illustrates a weekly motivational quote. She lives with her husband and daughters in Surrey, UK.

AN ALIEN ON ONE'S OWN PLANET...

 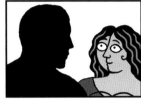

THE WAIT... THE LOOK...

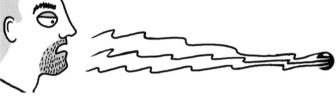

AND WORDS THAT FLY LIKE CANNONBALLS.

OUR CONFIDENCE OUR SELF-ESTEEM.

BUT WE WILL RISE AGAIN ... STRONGER. END

ABOVE © Kripa Joshi, 'Miss Motivation', *Shattered – The Asian American Comics Anthology* (A Secret Identities Book), 2012.

Gill Hatcher
(1987–)

Gill Hatcher is a cartoonist based in Lanarkshire, Scotland. Her work is often inspired by nature and conservation issues, as well as feminism and autobiographical stories. In 2009, she founded Team Girl Comic, a collective of Scotland-based cartoonists that met to talk about comics and to produce regular comics anthologies. 'I wanted to showcase women and girls in the alternative comics scene, as well as to entertain!'

The collective had an important social or community emphasis. It aimed to be 'strictly non-elitist and [to] invite anyone female-identified in or from Scotland to contribute to the comic, whether they create art professionally or just fancy giving it a go'.

ABOVE RIGHT © Gill Hatcher, *The Beginners Guide to Being Outside*, The Seagull Appreciation Society, 2015. Nominated for a 2015 Scottish Indie Comic Book Award, Hatcher's *The Beginners Guide to Being Outside* has Basil the Budgie take the reader on a journey to find out how climate change is affecting Scotland's seabirds.

Keara Stewart
(1985–)

Keara Stewart is an artist living and working in London. She edited *A Bit of Undigested Potato* (2015), an anthology on the theme of bad dreams and nightmares, with dreams from 40 creators.

'I decided to edit an anthology and invited both emerging and established creators from the zines and comics world to contribute alongside artists and writers.

'I launched the anthology at the 2015 Alternative Press Takeover zine fair.'

BELOW RIGHT © Keara Stewart, page from *A Bit of Undigested Potato*, 2015.

Amber Hsu

(1976–)

Amber Hsu (徐碧莉/ xúbìlì) is a British-Chinese-American writer, poet, film-maker, visual artist, and small-press publisher. She is the creator of the anthology artzine *Tiny Pencil*, and the inventor of *One Pound Poems* – a live, verse-making endeavour through which she also produces a series of illustrated poetryzines.

ABOVE © Amber Hsu, *There Was Once... A Short Comic*, 2015. A version of this comic originally appeared in Richy K. Chandler's *Tales of the Tanoox* anthology.

Sofia Niazi

(1986–)

Sofia Niazi is an artist, illustrator and educator based in London. In 2013 she set up *OOMK Zine (One of My Kind)*, a biannual publication about women, art and activism, with Rose Nordin and Sabba Khan. She co-founded DIY Cultures Fair (2013–2017) – a day-long festival exploring intersections of art, publishing and grassroots activism.

RIGHT © Sofia Niazi, 'Where to look for Scarf Pals', page from *Talk to the scarf 'cos the face ain't listening*, 2006. This early zine by Niazi playfully addresses some of the questions, assumptions and prejudices encountered by hijab-wearing women in Britain.

Katriona Chapman

(1978–)

Katriona Chapman
is an illustrator and
comic creator based in
London. She started
out as a children's book
illustrator and worked
with publishers all over
the world. Later she
moved into small-press
and comics, and in
2015 began publishing
a regular zine called
Katzine. She is currently
working on her graphic
novel, *Follow Me In*.

RIGHT © Katriona Chapman,
front cover of *Katzine* #2, self-
published, June 2015.

BELOW LEFT © Katriona Chapman.
Book cover for *Comic Book
Slumber Party's Deep Space
Canine*. Pencil with digital colour.
Avery Hill Publishing, 2017. 'For
this book cover we brought in
visual references to feminism,
LGBTQ rights and even the
European Union'.

BELOW RIGHT © Katriona
Chapman, page 24, *Follow Me In*,
Avery Hill Publishing,
September 2018.

Michi Mathias

(1959–)

Michi Mathias draws 'random' stories about the absurdities and annoyances of real life and enjoys using illustration to make complicated things clearer. After a distant past of trying to draw 'properly', her work has now veered toward a somewhat realistic but 'slightly wonky' style, using old-fashioned pen and ink and watercolour.

Donya Todd

(1986–)

Donya Todd is an artist, illustrator and comic book maker who specialises in telling tales through art. Her work is inspired by the magical, mystical and macabre which shines through in her narrative style. She studied illustration at the University of Plymouth and Hokkaido College of Art and Design in Japan. She is currently studying towards a master's degree in authorial illustration at Falmouth University.

LEFT © Michi Mathias, 'Banned by the word of God', Gosh Comics, 2015. 'LGBT-themed contributions were invited by Gosh Comics in London for a zine to be produced for Pride in 2015. I had a simple idea to show what nonsense it is to quote the Bible selectively.'

BELOW © Donya Todd, 'Pretty', 2016. Pages 3–4 from story included in *Broken Frontier Small Press Yearbook 2016*.

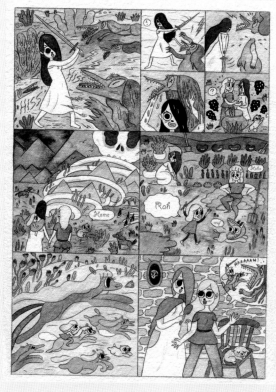
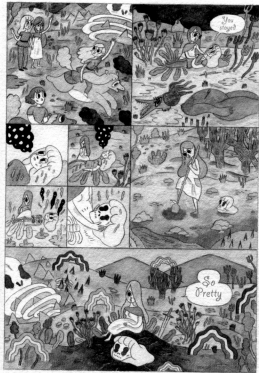

Comics festivals

Nicola Streeten

In spite of there being so many more women creators and participants, none of the mainstream comics festivals and comic conventions in the UK appear to have achieved a 50 per cent gender balance in their invited guest lists. There is also a continuing lack of representation of creators and participants of colour. However, alongside mainstream comic conventions in London, Birmingham and elsewhere, a number of festivals have been created in recent years, with an emphasis on small and alternative presses, which seek to redress that balance. A lively infrastructure for selling has developed around a market-stall model at comics festivals, and increasingly, these are being organized by women.

Since the days of the The UK Comic Art Convention (UKCAC) a British comic convention held between 1985 and 1998, which had a small-press and independent comics presence, inclusion has been an issue for women artists. Comica, started by Paul Gravett in 2003, is one of the festivals noted for its inclusion of women. It has hosted annual festivals and a series of events including small-press fairs in London.

Caption claims to be the UK's longest running comics festival, both organized by and showcasing the work of small-press and professional creators alike. Established in Oxford in 1992, by a team including Jenni Scott, Jeremy Day and Damian Cugley, Caption has most recently been hosted in Brighton by writer and journalist Alex Fitch of Graphic Brighton and Cartoon County.

The small-press and regional comics fairs also play a vital part in enabling creators to share ideas and develop their work. Comics are being produced from a range of different training backgrounds, for example Kathryn Briggs from fine art and Kristyna Baczynski from design.

In 2007, Thought Bubble – Leeds' Comic Art Festival was set up as a non-profit organization by cartoonist Lisa Wood (who also goes by the name Tula Lotay). This soon became the biggest festival of its kind in Britain. Wood's aim was to provide 'an annual celebration of sequential art in all its forms, including everything from superhero comics to independent and small-press artists and writers'. East London Comics & Arts Festival, London's biggest annual festival, founded by independent publisher Nobrow in 2012, celebrates both small-press publications and the community of individual artists and collectives from the UK and Europe. It is has an international reach that helps to push the boundaries of comics and illustration to a growing public. In 2013, the Lakes International Comic Art Festival, directed by festival organiser Julie Tait, was established in Kendal, Cumbria, with an international focus, modelled on the annual Angoulême International Comics Festival, France.

Elsewhere in the UK, the Bristol Comic and Zine Fair was founded in 2011 to 'celebrate the world of DIY and independent publishing'. In London, DIY Cultures has run since 2013, as an annual day festival, exploring intersections of art and activism. Also in London, Safari Festival, first set up by comics publisher Breakdown Press in 2014, celebrates 'new waves in contemporary comics and art'. The numerous zine and pop-up fairs in London and elsewhere are an indication of a grass-roots moment creating the festivals that the creators want to attend, and the many different comic art forms that they want to create.

One of the frequent small-press and zine fair visitors is Andy Oliver, who champions comics creators and small-press works in the online site Broken Frontier. His blog tracks the wealth of self-published zines and comics in print or that start and/or exist online, many of which are created by women. Many of the contributors to his annual anthology of creators to watch are women. The following were included in the Broken Frontier Small Press Yearbook.

Ellice Weaver

(1993–)

Ellice Weaver started making comics and zines when she was 20 years old, creating autobiographical stories. She now enjoys creating fictional comics. Her graphic novel *Something City* was published by Avery Hill Publishing in 2017. A common theme in Weaver's work is the exploration of the effects of ageing and our attitudes to growing older.

Born in England, she currently lives in Berlin. She won the Broken Frontier Awards 2017 'Best Artist' category.

EdieOP

EdieOP is an illustrator, creator of comics and 'truly awful things'. She likes to draw in inks and crayon, occasionally paints, and works with collage and mixed media to create macabre and sometimes slightly absurd illustrative narratives and comics. She is the author and illustrator of *Maleficium* (Avery Hill Publishing, 2014), which was shortlisted for the British Comic Awards Young Person's category in 2015. She is currently working on her next graphic novel.

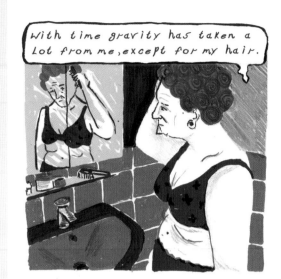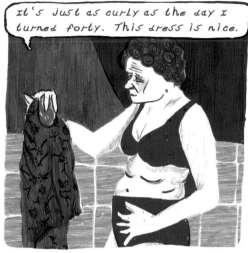

ABOVE © Ellice Weaver, 'A day in a life', 2015. Web comic, personal work.

LEFT © EdieOP, 'The Bad House Guest', unpublished.

Kim Clements
(1990–)

Kim Clements' first comic 'Rabbit Thoughts' debuted at the well-loved Bristol Comic and Zine Fair in 2015 and was nominated for a Broken Frontier Award that same year. Known for illustrating in a child-like manner, Kim Clements tackles themes of loneliness, heartbreak and emotional recovery.

Emma Raby
(1987–)

Emma Raby is an illustrator of silent comics about history and folktales. She has an MA in Children's Book Illustration from the Cambridge School of Art.

'I self-publish small-press comics and have attended various comic fairs around the UK. *The Sea Serpent* (self-published, 2017) was my first venture into comics.'

ABOVE © Kim Clements, *Rabbit Thoughts*, 2015. This autobiographical comic focuses on the loneliness of a young woman in the big city.

LEFT © Emma Raby, *The Sea Serpent*, page 5, self-published, 2017.

Rozi Hathaway
(1990–)

Rozi Hathaway is a comic creator, illustrator and zine-maker currently based in Bournemouth. Winner of the Broken Frontier Breakout Talent Award in 2016, Hathaway has self-published several comics: *The Red Road*, *Njálla*, *Ø* and *Sneaky Business*. Her recent book *Cosmos & Other Stories* is out now with Good Comics.

RIGHT © Rozi Hathaway, 'Afloat', August 2015, *Broken Frontier Small Press Yearbook 2016*. Ink and gouache. Hathaway's wordless short story focuses on the life of a boy seemingly living alone in abject poverty.

Alice Urbino
(1993–)

Alice Urbino is a Bristol based comics artist and illustrator. Her work is a fantasy-tinged exploration of living with depression and anxiety.

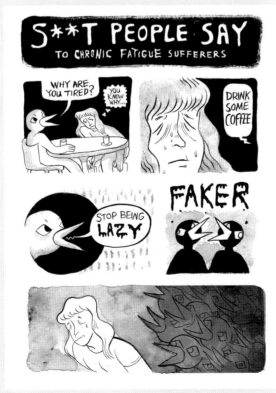

RIGHT © Alice Urbino. *Shit People Say to Chronic Fatigue Sufferers*. Ink, 2014.

The graphic novel

Nicola Streeten

Several publishers have been set up to specialise in the publication of graphic novels. These include SelfMade Hero (2007–), Avery Hill Publishing (2011–), Nobrow Press (2008–), Soaring Penguin Press (1998–). More established publishing companies such as Jonathan Cape (1921–), Bloomsbury (1986–), Myriad Editions (1993–) and Jessica Kingsley Publishers (1987–) have introduced graphic novels to their lists. The graphic novel has become increasingly popular and respected as an art form.

The 'graphic novel' or long-form comic presented in book form represents a different symbolic space to the mainstream superhero comic within contemporary culture. Associated with literature and serious subject matters, this particular form has been introduced to a new, non-traditional comic-reading public, many of whom are women. The publication of *Maus* by North American writer and artist Art Spiegelman (1986) paved the way for the publication and popularity of autobiographical comics. *Maus* is the story of Spiegelman's parents, Vladek and Anja, from their first meeting in pre-war Poland to their survival of the death camps at Auschwitz and Dachau. In 1992, it was the first graphic novel to win the Pulitzer Prize; it also became a publishing phenomenon, selling over two million copies worldwide.

In Britain a new audience was introduced to the graphic novel form in 2001, when US author Chris Ware won *The Guardian* First Book Award with his autobiographical graphic novel *Jimmy Corrigan, The Smartest Kid on Earth* (2001). This story of an abusive relationship between a man and his son was moving into subject matter that dealt directly with everyday human experience. In 2012, Bryan and Mary Talbot won the Costa Award for Best Biography for *Dotter of Her Father's Eyes*, both a graphic biography of James Joyce's daughter, Nora, and a memoir of Mary Talbot's father, a Joycean scholar. This win for a book in graphic novel format was a first for this prestigious literary prize.

In the line-up of the most successful graphic novels, women's works are among the best-selling. Iranian born and Paris-based Marjane Satrapi's graphic novel *Persepolis* (2004–5) uses simple line and black shading to present her story of Tehran in the Khomeini years – a period that is complex and that many Western readers do not know about. It has sold well over a million copies and has been translated into 24 languages.

Another significant work is American cartoonist Alison Bechdel's *Fun Home* (2006), documenting the autobiographical story of her sexual identity as a lesbian and her relationship with her father, a closet homosexual. Her literary references throughout ensured an appeal to an intellectual and academic readership, as well as her loyal lesbian following from her 1980s cartoon strip, 'Dykes to Watch Out For'.

The insistence of 'truth' through the auto-biographical voice, applied to the comics form, has made the graphic novel an attractive platform for personal stories. Since the 2000s, an increasing number of autobiographical graphic memoirs by women have been published in Britain that address issues around identity and personal trauma. Arguably, the increase in the publication of women's work is a consequence of influential women in the industry who are shaping the graphic novel lists. Examples include publishing director Jessica Kingsley at Jessica Kingsley Publishers, creative director Corinne Pearlman at Myriad Editions, Emma Hayley, publishing director at SelfMadeHero, and crowd-funding publisher Unbound (2010–) where commissioning editor Lizzie Kaye is developing a graphic novel list.

Graphic medicine

Graphic medicine was a pivotal grassroots activity. It provided a women-friendly stage, growing the comics community and injecting a new readership from outside the comics industry. Ian Williams, an artist and GP based in North Wales, coined the term 'graphic medicine' in 2007 while studying for a Master's Degree in Medical Humanities. Identifying the potential of the application of comics within healthcare, he quickly drew an online following. Reflecting its origins on the internet, the graphic medicine movement is now widely accessible online. The Graphic Medicine Conference, launched at the University of London in June 2010, is an annual international event.

A unique feature of the conferences is the interdisciplinary mix of presentations and attendees. They include participants who are creators, academics, and people working in healthcare professions. This interaction has allowed practitioners to discover different ways in which to communicate with patients, among themselves, and with the general public.

OPPOSITE PAGE © Hannah Eaton, page from work-in-progress, *Blackwood*, Myriad Editions, 2019.

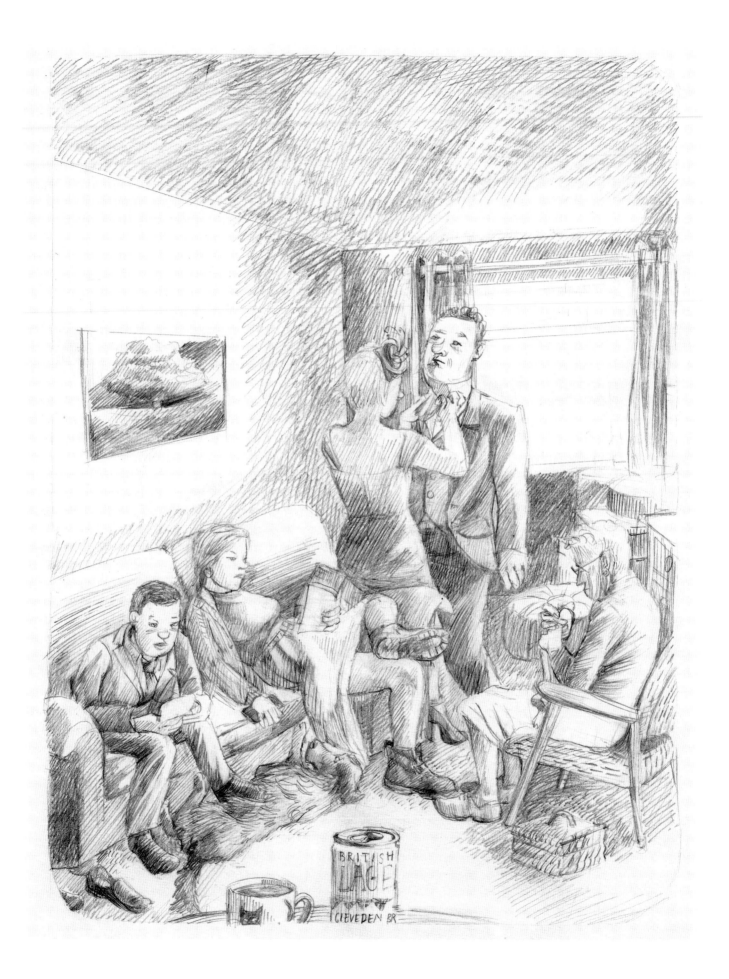

Muna Al-Jawad

(1977–)

'I work full time as an NHS consultant in elderly medicine in Brighton. The original comics centred around my superhero alter-ego – Old Person Whisperer.

'I think comics are the ideal way to challenge as people don't see them as threatening and so you can smuggle in a subversive idea or message.

'I drew this (right) when I started a PhD using comics to research my experiences of medical practice and those of other doctors. I use comics to research practitioner identity, attitudes toward death, clinicians who look after people with Parkinson's disease, dementia care, NHS leadership and the underlying moral basis of healthcare practice. I found I could incorporate theory into practice by incorporating ideas of "illness narrative" from Arthur Frank and resilience from Nietzsche into the comic shown here.'

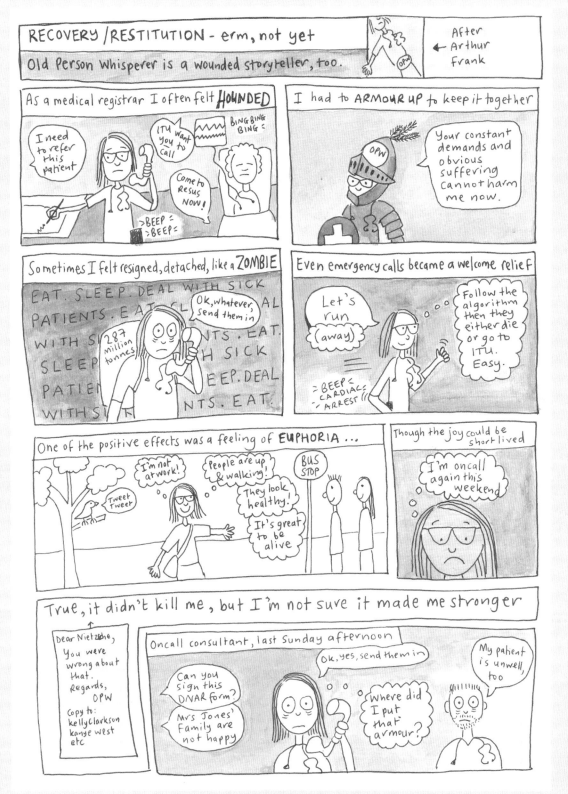

ABOVE © Muna Al Jawad, 'Recovery/ Restitution - erm, not yet: Old Person Whisperer is a wounded storyteller too', 2013.

Nicola Streeten

(1963–)

From 1996 Nicola Streeten worked as an illustrator in editorial, and for the charity and business sectors. From 2008 she applied her cartoon style to producing her graphic memoir *Billy, Me & You* (2011).

'This documents my personal experience of bereavement following the death of my two-year-old son. It was originally serialised in Liquorice (2007–2010), a self-published zine. I wanted the book to be about my response to your response to my grief.'

She co-founded the forum Laydeez do Comics in 2009 and her doctoral research was on feminist cartoons and comics in Britain from 1970.

She is currently working on 'A year at 55', a series of online comics that reflect the experience of menopause and aging.

LEFT © Nicola Streeten, *Billy, Me & You*, Myriad Editions, 2011.

BELOW © Nicola Streeten, 'A year at 55', 2017, Instagram: @nicolast.reeten.

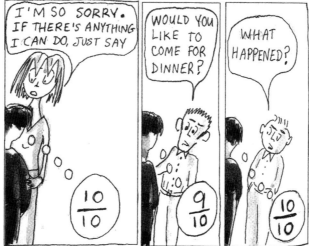

Paula Knight
(1969–)

Paula grew up in Northeast England and studied Graphic Design/ Illustration at Bristol Polytechnic (UWE). She works as an author, illustrator and comics creator. As well as her graphic memoir, *The Facts of Life* (Myriad Editions, 2017), she has also self-published comics, illustrated children's books and written three picture books.

Knight's memoir *The Facts of Life* (Myriad Editions, 2017) is a graphic novel exploration of the expectations of women to procreate triggered by her own upbringing and experiences of miscarriage and childlessness.

'My intention with this work was to take part in the conversation about pressures on women to become mothers and the issues around why people try for children later in life – rather than the rhetoric peddled in the media about women "leaving it too late". It examines what it's like not to have children in a society where "family" means "children".

'Human communication is a symbiotic dance of the visual and verbal, as is comics. It therefore felt like a very powerful medium with which to tackle personal subject matter that has historically been silenced by society.'

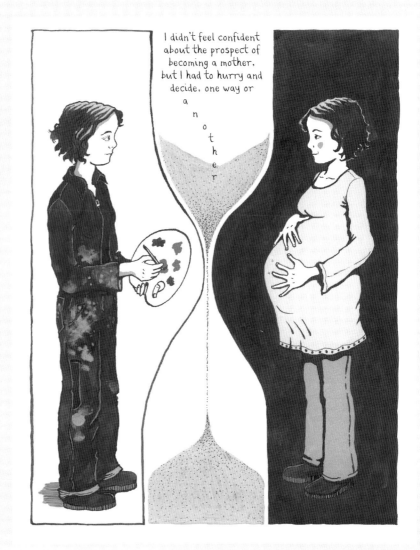

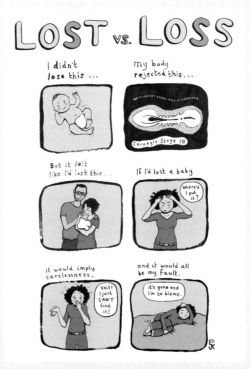

ABOVE © Paula Knight, 'Biological Clock-up', *Bearpit Zine #4*, 2012; *The Facts of Life*, Myriad Editions, 2017.

LEFT © Paula Knight, 'Lost vs Loss', 2013, self-published in *X Utero, A Cluster of Comics*.

Matilda Tristram

(1982–)

Matilda Tristram is an animator and illustrator from London. Her autobiographical comic, *Probably Nothing: A Diary of Not-Your-Average Nine Months* (Penguin, 2014), was written after being diagnosed with cancer while pregnant. She teaches at Kingston University and co-wrote the BAFTA-winning animation *Dipdap*. Her comics have appeared in *The Guardian*, *Art Review*, *Vice* and *Glamour*.

'When I was pregnant with my first child, I was diagnosed with stage three cancer. During the treatment that followed, I wrote a diary comic about my life. I put the comic online so people would know how we were doing. Friends retweeted my posts and quite soon many more people were following our progress: other cancer patients, comics enthusiasts and medics. Just before my son James was born, *The Guardian* printed an extract, then I was offered a book deal.

'I found words used to describe pregnancy and pregnant mothers infantilising. Growing foetuses known as "bump" and "bean". As soon as I got pregnant, my stomach became my "belly" and it was normal to talk about myself in the third person.'

FEBRUARY

I was wearing my favourite T-shirt on the day of the diagnosis. I never want to wear it again.

The flat is full of flowers.

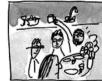

We all cram round our tiny kitchen table and start getting used to things. 'The great thing about your tiny kitchen is that I can reach anything without leaving my seat!'

Mum tells us something about her PhD; 'It was the publisher who censored it, not the translator at all!'

No one can bring themselves to write 'cancer' in a card.

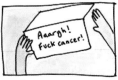

Apart from one friend who's had it before.

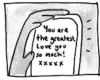

Lots of people send lovely messages.

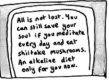

And not so lovely ones.

I get annoyed when people ask if they can pray for me. 'Do it if it makes you feel better!'

And when people I don't know very well ask me how I'm feeling. 'How do you fucking think I'm feeling!?'

And when people send me emails about miracle cures. 'Lemon peel? Broccoli? I've been eating broccoli my entire life!'

And when everyone wants to visit me all at once. 'I don't want to see ANYONE!'

I lie on the bed in a patch of sun and remember lying on a rock by the sea at Point d'Endoume in Marseille.

Me and Tom talk about the other holidays we'll go on and I cry.

Tom fixes a tyre and I mend my slipper on the front step. It's good to be outside.

Brian Cox on the iPad helps me to fall asleep at night.

ABOVE © Matilda Tristram, page from *Probably Nothing*, Penguin, 2014.

Rachael Ball

(1964–)

Rachael Ball is a cartoonist and illustrator. She started producing regular strips for cult comic *Deadline* in 1988. Her graphic novel *The Inflatable Woman* (Bloomsbury, 2015) combined magic realism and the experience of breast cancer. Her forthcoming graphic novel *The Wolf Man* is based on children's experience of bereavement. She is presently one of the co-ordinators of the London branch of Laydeez Do Comics.

'I produced *An Inflatable Woman* over two and a half years, blogging it monthly to ensure I stuck at it. Meanwhile, I was teaching art in a secondary school three days a week. It was a surreal response to my experiences of breast cancer. It is a tale of anxiety centring on Iris, a zoo keeper who, when she is diagnosed with cancer, develops an internet romance with Sailorbuoy39 to distract herself from the horror of the experience.

LEFT © Rachael Ball, *The Inflatable Woman*, Bloomsbury, 2015.

BELOW © Rachael Ball, 'Ruby Chan in Larry', *Deadline 45*, 1992.

Katie Green
(1983–)

Katie Green grew up in the London suburbs and moved to Bristol in 2002 to study, before moving to her current home in Devon. She has been self-publishing a bi-monthly zine, *The Green Bean*, since May 2010. Her graphic memoir, *Lighter Than My Shadow* (Jonathan Cape, 2013), some 500 pages long, took almost five years to complete.

'*Lighter Than My Shadow* was a personal project documenting my process of recovery from an eating disorder and sexual abuse.

It began formally as a degree project when I was studying illustration and I was offered a publishing contract by Jonathan Cape in 2010 while still early in the development stages.

'I decided there was a need for a book that told the unflinching truth about how hard recovery is, but showing that it is indeed possible, and worth it. Writing that book was part of my motivation to get better.

'I still cartoon, but not full-time because the pressure to make it financially viable is stressful and not conducive to creativity.'

ABOVE © Katie Green, 'Knitting Saved My Life', *Pom Pom Quarterly*, Issue 11, Winter 2014.

BELOW © Katie Green, *Lighter Than My Shadow*, Jonathan Cape, 2013.

Henny Beaumont
(1967–)

Henny Beaumont's graphic memoir *Hole in the Heart*, published in 2016, was short-listed for the Myriad First Graphic Novel Competition. Her work has featured on BBC Radio 4 and in *The Guardian*, *Daily Mail* and *The Sun*. She is currently cartooning for *The Canary* and *Community Living* magazine, working on new graphic fiction and lecturing.

Henny Beaumont's graphic memoir *Hole in the Heart* tells the story of bringing up her daughter, Beth, who was born with Down's syndrome. In it, Beaumont shares her family's experience from her daughter's birth in the hospital to toddlerhood and schooldays.

'I wanted to talk about how we see disability and I wanted to make disability (particularly Down's syndrome) more visible. Things have changed a bit, but inclusion in adverts for example is often tokenistic. There is a lot of work to be done.'

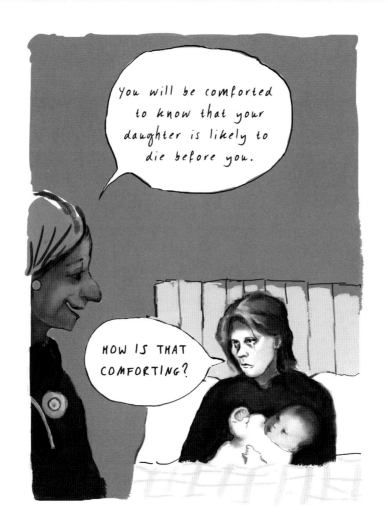

LEFT © Henny Beaumont, *Hole in the Heart*, page 47, Myriad Editions, 2016.

BELOW © Henny Beaumont, *Hole in the Heart*, pages 8–9, Myriad Editions, 2016.

Eliza Fricker

(1979–)

Eliza Fricker is an illustrator and graphic designer from Brighton. She also designs wallpapers for an interiors company (Baines&Fricker) that she set up with her husband. They have worked with various retailers including Heals, Liberty London and Anthropologie. Her work explores the banality of English suburban life. *Just Getting Old* is her first full-length graphic novel about her mother's decline, diagnosis and eventual recovery from a brain tumour.

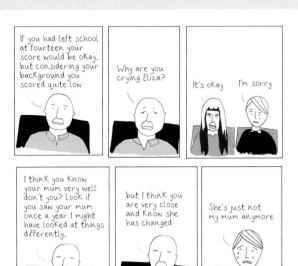

LEFT and ABOVE © Eliza Fricker, cover and page from *Just Getting Old*, 2016, unpublished. 'The work was self-initiated. I began it while my mum was still recovering from her brain surgery and I wanted to record what had happened.'

Zara Slattery

(1971–)

Zara Slattery is a comics artist and illustrator living in Brighton. She is currently working on an account of contracting a severe streptococcal infection in 2013 which resulted in her losing a limb.

'The suddenness of the illness, two weeks in a harrowing coma, that's best described as a "drug induced purgatory", and the consequences of losing a limb are all areas I'm planning to explore through pictures.'

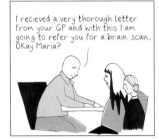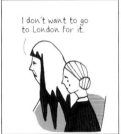

LEFT © Zara Slattery, 'Everlution', 2013, comic published on the web after a presentation to the Graphic Medicine Conference in Dundee in 2016. https://zaraslattery.com/2016/08/21/coma-comic-presentation/

Helen Blejerman
(1970–)

'I am a Mexican writer and artist living in the UK. My work has been shown in anthologies, and in cultural and art magazines. My first graphic novel *Lulu La Sensationnelle* was published in France by Presque Lune Editions. I have produced and co-produced cultural radio shows, as well as being a regular guest at the BBC Sheffield. As an associate lecturer in Fine Art at Sheffield Hallam University, I focus on the innovation in art education. At the moment I'm working on my new graphic novel and I just co-wrote the script for a feature-length film.

'I focus on the potential poetics that the space between image and language provides. I began working on *Lulu* in 2013. I was using my work to speak about a family secret. After a long decay, my mother was finally diagnosed with schizophrenia in 1992. When I was a child, the family treated her illness with an immense silence, or perhaps we all treated it with a great ignorance, which became the inspiration for this work of fiction based on biography.'

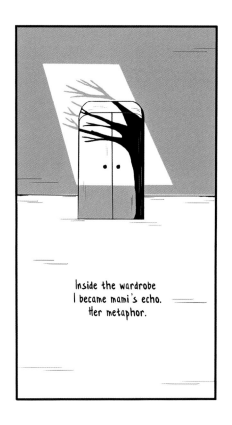

RIGHT © Helen Blejerman, 'Inside the wardrobe', page from *Lulu La Sensationnelle*, Presque Lune Editions, 2014.

Rebecca Fox
(1983–)

'I grew up in the South of England and spent most of my childhood outside, or in the library.

'I doodled in the margins throughout a BA at Oxford Brookes and an MA in Postcolonial Literature at Macquarie University, Australia. I now write and draw comics about philosophy and people.'

RIGHT © Rebecca Fox. Cover image for *Murmurs of Doubt.* Pen and watercolour. Ockham Press, June 2017.

Aleesha Nandhra

(1993–)

'I was told by someone once that they didn't think that my work was my work – they had expected a guy to have made it because they found it "masculine".'

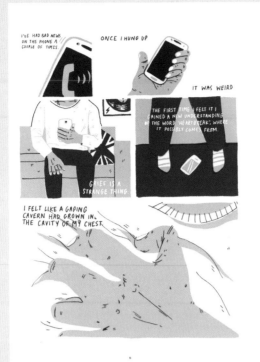

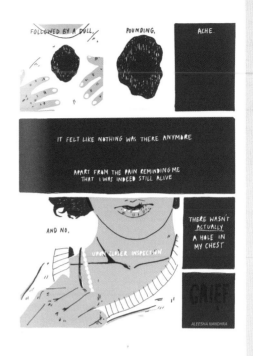

ABOVE © Aleesha Nandhra, 'Grief', *OFF LIFE* No.13, 2016.

LEFT © Teresa Robertson, 'Dying', *Life, Death and Sandwiches*, 2014.

Teresa Robertson

(1959–)

Teresa Robertson has illustrated for over 30 years and has been making graphic stories since 2014.

'Dying' was shortlisted for the Observer/Cape/Comica Graphic Short Story Prize 2014 and was a finalist in the John Ruskin Prize/Recording Britain Now in 2016. It forms part of her first collection of short graphic stories: *Life Death and Sandwiches*. She has recently completed *Twins*, a full-length autobiographical story.

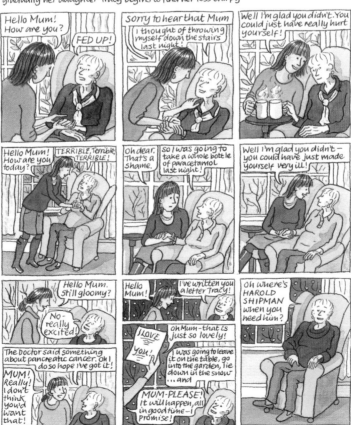

Kim L Pace
(1966–)

Artist Kim L Pace makes sequential drawings, books and installations that have been exhibited extensively, including over 20 solo shows.

She has also received numerous awards for her work.

Kim conceived the exhibition 'Cult Fiction – Art & Comics' (Hayward Gallery Touring) and is currently working on her first graphic novel.

The smashed front door, shards of glass shattered across the front path I would never again cross on my way to school

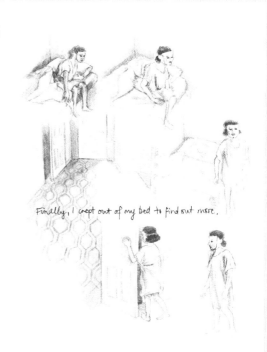

Finally, I crept out of my bed to find out more.

ABOVE © Kim L Pace, 'Shattered Glass', 2017; 'Crept In', 2017. Images extracted from graphic novel in progress.

BELOW © Emily Haworth-Booth, an extract from *Colonic*, 2013. Winner of the Observer/Cape/Comica Graphic Short Story Prize, 2013. Ink, pencil and digital processes. It appeared in print in *The Observer New Review* on 27 October 2013.

Emily Haworth-Booth
(1980–)

Emily Haworth-Booth won the 2013 Observer/Cape/Comica Graphic Short Story Prize and teaches graphic novel courses at the Royal Drawing School in London. She has an MA in Children's Book Illustration from Cambridge School of Art and her first picture book will be published by Pavilion Children's in 2018.

'To be successful in comics, a woman must have a good part-time gig (and/or a supportive partner, particularly if there are children), a support network of fellow 'sufferers' of the comics affliction, lots of patience, a bizarre all-consuming love of drawing things in little boxes, and a belief, bordering on the religious, and preferably unquestioned, that this is of great importance to the world.'

Now I'm just going to pop this tube into your bum

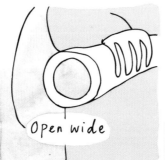

Open wide

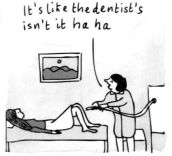

It's like the dentist's isn't it ha ha

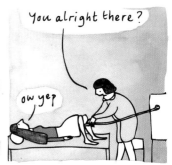

You alright there?

ow yep

Laydeez do Comics
and the everyday

Nicola Streeten

Of course not all comic works by women today are being produced around health issues; there is a huge variety of subject matter. My own introduction to the form began with an interest in the autobiographical and the everyday. In 2007, while working towards a Master of Research Degree and a graphic novel based on the experience of the death of my child, I attended a number of events in Britain focused on the graphic novel. Here I met Sarah Lightman, who had begun a PhD researching autobiographical comics. In July 2009, we met at the Wellcome Collection in London to look at the exhibition of British artist Bobby Baker's 'Diary Drawings'. The exhibition was of loosely drawn line and watercolour drawings, which incorporated text. They were based on Baker's personal experience of her depression.

With Baker's images in the background, we discussed over coffee what 'comics' could be. We decided to set up a group for the discussion of comics works (with the loosest definition) that focused on life narratives, the drama of the domestic and the everyday. Our decision was prompted by the lack of such a forum existing, and the isolation of working on our own creative projects.

We co-founded Laydeez Do Comics, 'like a combination between a book club and a series of TED talks', with meetings held monthly at The Rag Factory. The venue had been previously introduced to us by a London Zine Symposium organised by Edd Baldry. This was the first graphic novel salon to exist; women-led but not women-only. It was initially modelled on a book group, but soon developed as a platform for invited guests to present their works. Advertised online to a public audience, it was free of charge to attend. Initially, it attracted around 20 people but by 2010 it had grown to around 100 each month, establishing itself as a hub of the small British comics community.

The emphasis has always been on providing a space to test new works and ideas, where emerging artists present their work alongside more established practitioners. Guests are not restricted to comics creators but include academics, film-makers, writers, artists and publishers. It has been a grassroots activity, based on goodwill with an interest in stressing the importance of social interaction, yet it has relied on the internet and social media for promotion and to establish a global reach. Documentation has been archived online through a guest 'bloggess' each month. This activity has contributed to the professionalisation and academisation of the comics form through grassroots activity. It soon became an event that national and international publishers, critics, festival organisers and academics from the industry frequented to discover new works – enhancing the industry. At the time of writing, Laydeez Do Comics has spurred branches and pop-ups in Leeds, Bristol, Glasgow, Birmingham, Brighton, Dublin, Chicago, San Francisco, New York, Israel and the Czech Republic. The works on the following pages show a use of the directly autobiographical or diary form. These are followed by less obviously autobiographical work, where the focus is around issues pertinent to the cartoonists' interest.

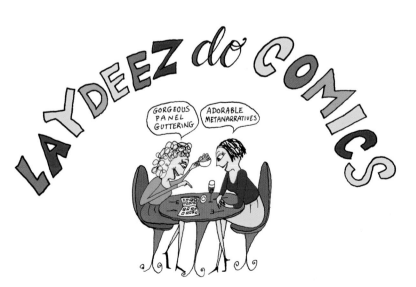

LEFT © Nicola Streeten, logo design for Laydeez Do Comics, 2009.

Sarah Lightman
(1975–)

Sarah Lightman is an artist, curator, and co-founder and co-director of Laydeez Do Comics. She edited *Graphic Details in Essays and Interviews* (McFarland) that won an Eisner Award (2015), The Susan Koppelman Prize (2015) and a Jordan Schnitzer Award (2016). She is the creator of the graphic novel, *The Book of Sarah* (Myriad Editions, 2019).

'My work has become increasingly antagonistic and critical of the patriarchal orthodox Jewish and Northwest London middle class world I grew up in.

'It was only when I found the world of comics, that I felt I was part of a wider movement, and that I didn't need to apologise for what I was doing. I had found my people.'

You should know. I really love Charlie. Just 2 months after our 1st date I travelled to Australia to meet him. We flew straight to Ayres Rock. It was perfect

ABOVE © Sarah Lightman, 'The Reluctant Bride' from *The Book of Sarah*. Myriad Editions, 2019.

RIGHT © Francesca Cassavetti, *The Most Natural Thing in the World*. Fabtoons, 1988.

Francesca Cassavetti
(1958–)

Francesca grew up in France reading comics, watching old movies, listening to rock music and drawing. She studied at art college in England where she discovered punk. Her work is often autobiographical. *The Most Natural Thing in the World* (1988) was drawn while raising her children and *Panic Attacks*, shortlisted for the 2014

Myriad First Graphic Novel Competition, was based on her life in Paris. Her work has appeared widely in anthologies including *Double Dare Ya*, *The Strumpet*, *Ink + Paper* and *Solipsistic Pop*.

'In the 90s I began creating what became my graphic novel, *The Most Natural Thing in the World*, while caring for young children, as a way to express my frustrations and to hang on to my sanity.'

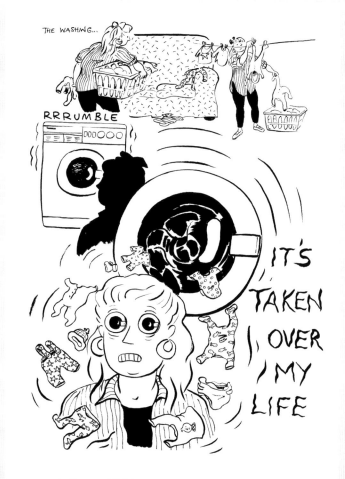

Penelope Mendonça
(1969–)

Penelope Mendonça is a graphic facilitator/cartoonist with a background in health services, advocacy and facilitating public engagement processes. Her work can be seen in *Varoom Magazine*, *Art Monthly*, the *International Girl Gang Anthology* (Angoulême International Comics Festival) and *Ink Magazine*. She is doing a practice-based PhD at Central Saint Martins, University of the Arts London. Her forthcoming book will be published by Jessica Kingsley Publishers.

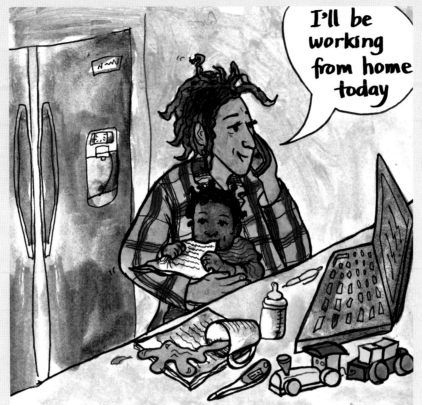

LEFT © Penelope Mendonça, *Mosaic Mothering*, 2017. 'This is one of hundreds of drawings produced as part of my journey to motherhood.'

BELOW LEFT © Katie Kirby, 'Let's get drunk and say stuff we shouldn't'.

BELOW RIGHT © Katie Kirby, 'You're weird but I like that'.

Katie Kirby
(1980–)

Katie Kirby is a writer and illustrator from Brighton. Her two *Sunday Times* bestselling books *Hurrah for Gin: A Book for Perfectly Imperfect Parents* (Coronet, 2016) and *The Daily Struggles of Archie Adams* (Coronet, 2017) are collections of cartoons and writing on early years parenthood, developed from her blog about her struggles as a parent. Since then she has successfully marketed the cartoons as greetings cards, prints, stationary and calendars.

Elizabeth Querstret

(1985–)

'I create a lot of web-based autobiographical strips, which look at brief snapshots of my day-to-day life. Topics I explore can range from the joy of small observations, through to social injustice. I am very honest on paper and will often expose my vulnerabilities.

However, I also try to find the positive in most situations.

'For a long time I was creating comics without realising it. Drawing is something that is done in my spare time.'

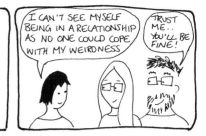
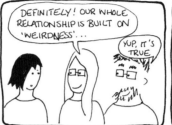
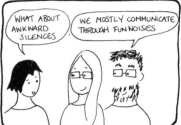

Philippa Rice

(1985–)

Philippa Rice is an artist who works in a number of different mediums including comics, illustration, animation, model-making and crochet. Her works include the collage-based webcomic *My Cardboard Life* and stop-motion animated characters. Philippa's autobiographical comic book, *Soppy*, was a *New York Times* bestseller in 2016.

'At the time I made *Soppy* I was just about making a living from self-published comics. I was mostly focusing on my webcomic, *My Cardboard Life*. I was living with my partner in a rented house and started writing diary comics about living together.

'*Soppy* was initially a 16-page self-published risograph mini-comic, which I later expanded. It was a side project at first but I kept making more and eventually turned it into a book.'

Charlotte Bailey
(1992–)

'I am self-taught from my nan's art magazines and a big red glossy hardback book called *How to Draw Anything*. I began making comics post-university when I was on the dole and searching for jobs. It was a way to show something for my time.

'Creating a space for artists to share their experiences is probably one of the best things I've ever been a part of. I started hosting Laydeez do Comics in Birmingham in 2016 so that I could draw inspiration from other artists. The organising and marketing experience from doing that on a bi-monthly basis also landed me my first "real" job.'

RIGHT © Charlotte Bailey, 'Swungover', Thought Bubble Comic Art Competition, 2016.

Hannah Eaton
(1975–)

Hannah Eaton was born in London and lives in Brighton. Her graphic novel, *Naming Monsters* was published by Myriad Editions in 2013. She is an artist writer and performer and works with young people in care. Her second graphic novel, *Blackwood*, will be published in 2018.

Naming Monsters was published after it was shortlisted for the 2012 Myriad First Graphic Novel Competition.

'I try to write fiction based in reality, with a few ghosts around the edges. I'm very interested in the interactions between political events – war, inequality, the making and breaking of laws – and familial trauma and people's emotional lives.

'This is what I'm overwhelmingly trying to do in my next graphic novel, *Blackwood*, which is partly a historical novel as well; I feel very strongly that the twentieth century needs revisiting in our imaginations, unsentimentally and a bit more often, given that it's only around the corner.'

BELOW RIGHT © Hannah Eaton, *Naming Monsters*, page 136, Myriad Editions, 2013, We follow Fran as she traverses London attempting to come to terms with the loss of her mother.

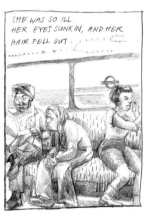
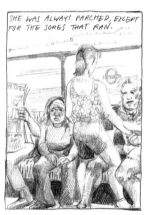
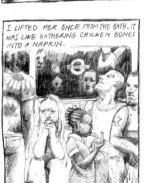
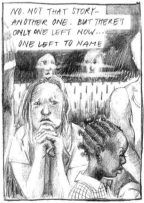

Ellen Montelius

(1964–)

Ellen Montelius has always drawn comics for personal projects and was motivated by the opportunity to submit one of her stories to the 2014 Myriad Editions First Graphic Novel Competition. She was long-listed and has been self-publishing short story comics since 2015. She is currently working on a comic about bees.

RIGHT © Ellen Montelius, pages from *Vanishing Point*, 2016. This self-published comic is the story about the joy of play and memory illustrated in a surreal encounter between a young girl and an old woman.

Wallis Eates

(1975–)

London Laydeez Do Comics co-ordinator, Wallis Eates, is a comics artist whose autobiographical works have been shortlisted for the Broken Frontier Awards and other prizes. She works with many community groups: her comic book, *Like an Orange*, is about the brain injury survivors she met at the charity Headway, and will be published by Unbound Books in 2019.

'When I was in my thirties, I began to address the things I felt had been holding me back. I started off with basic illustrations of memories, and some prose about people who were haunting my mind, bunged it all on a

Tumblr and Facebooked it. No sooner had I done this than I found the comics community and everything started to make sense. I went to Laydeez do Comics and in 2014 I entered and was shortlisted for the Myriad First Graphic Novel Competition with an extract from *Mumoirs*. Getting into this medium was a life-changer.

'*Mumoirs* is an autobiographical account of being an only child with an unmarried mother in the 1980s. It explores the dynamic of our relationship against the social backdrop of the era.'

RIGHT © Wallis Eates, 'End to End', *Fear of Mum-Death and the Shadow Men*, self-published, 2014.

Ottilie Hainsworth
(1969–)

Ottilie Hainsworth studied illustration at Glasgow School of Art and The Royal College of Art, where she wrote 'Elvis and Me'. In 2014 she contributed to *Brighton: The Graphic Novel*. She has been drawing her diary since 2015.

Her first graphic novel *Talking to Gina*, published by Myriad Editions in 2017, is an autobiographical story about the strong emotion involved in owning a dog.

'I feel lucky to be around at a time when diverse people's real life experiences are being valued and explored in comics.'

FAR LEFT © Ottilie Hainsworth, drawing from *Talking to Gina*, Myriad Editions, 2017.

LEFT © Ottilie Hainsworth, Diary Entry, personal work, 2015. 'I've been working on this diary for almost two years now (2015–2017). It's a self-motivated project, as yet unpublished.'

Ginny Skinner
(1976–)

I started making comics with my sister Penny. We self-published *The Art Room* in 2009 and in 2013 our graphic novel *Briony Hatch* was published by Limehouse Books. *White Stag* is my most lengthy solo graphic novel project. It has eight chapters, each of which takes place on one of the festivals of the pagan wheel of the year. Other works of mine appear in *The Strumpet* No.5 and *Meanwhile*.

'I became irritated at how much female nudity there was in comics compared to the amount of male nudity. I created a character called Toy whose entire narrative was ending up naked at the end of the page. *Toy* ran as a weekly online comic on a website called 9to5cafe and also appeared in the *GirlFrenzy Millennial*.'

RIGHT © Ginny Skinner, from Chapter Two: Ostara, *White Stag*, 2011. 'White Stag is a solo project about the killing of a stag in an isolated rural village, and what it is like for the younger generation growing up there.'

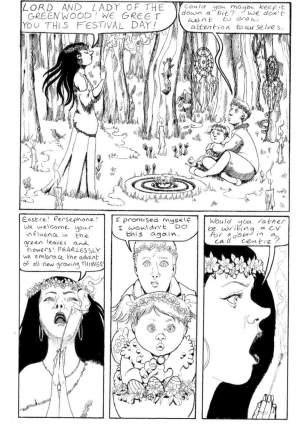

Jade Sarson

(1990–)

Jade Sarson is a comic artist and illustrator. She was nominated for Best Emerging Talent in the 2013 British Comic Awards. She is the creator of the teastained webcomic *Cafe Suada* and the graphic novel *For the Love of God, Marie!* (Myriad Editions, 2016).

Sarson's graphic novel *For the Love of God, Marie!* was published after an extract from it won the Myriad First Graphic Novel competition, 2014.

'When I left university I thought an agent might be able to help me gain some work, so I signed up with one. But they wanted me to draw generic, boring children's illustrations with typical gender roles such as ballerinas for girls and astronauts for boys.

'I've always wanted to create interesting characters that could teach life lessons, regardless of their gender, race, orientation, or any other aspect of their background. In that way I hope to promote acceptance.'

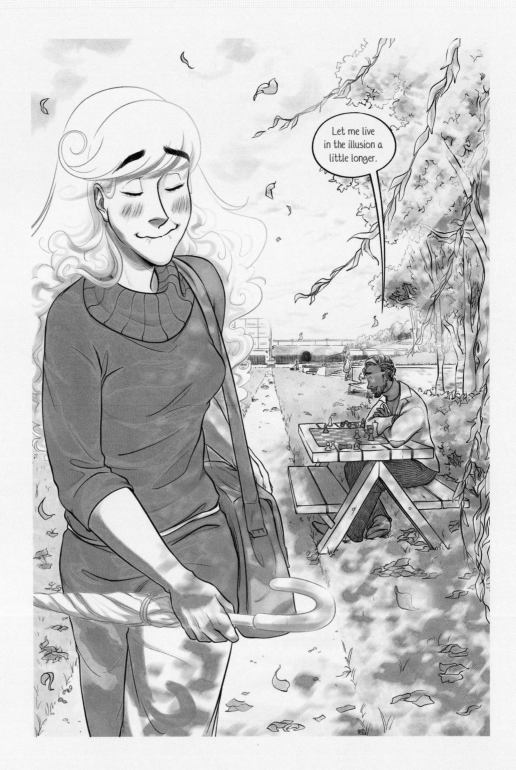

ABOVE © Jade Sarson, *For the Love of God, Marie!* page 84, Myriad Editions, 2016.

Ruby Elliot

(1993–)

Ruby Elliot is an illustrator, cartoonist and author from London.

She is a self-taught artist, and 'makes work as a reflex to experiences and emotions so that they become easier to metabolise'.

She also likes laughing, dogs, shouting and jam.

'For the last seven years or so, I have been sharing my work online on a blog and social media. Most of my work is autobiographical, and involves drawings of me, or the character of "me" I've created. She is an image of how I often feel: a long-haired, grumpy looking and disproportionately large-bodied entity. I occasionally posted photos of myself. As soon as I did, I received a torrent of comments about my physical appearance and weight, expressing dismay and often real anger that I didn't appear to exactly resemble the way I'd drawn myself.

'People called me a liar and an attention seeker. I bring this up because I know many cartoonists, both male and female who depict themselves in a variety of ways, from the objectively accurate to the wild and very "ugly". I have never seen a male cartoonist or webcomic artist so heavily criticised for their appearance in relation to how they draw themselves, but I've seen it happen to numerous female cartoonists where what they "actually look like" becomes weirdly important to strangers.'

BELOW © Ruby Elliot, 'Crap Kingdom', online personal work, 2016.

Sally Ann Hickman

(1980–)

Sally-Anne Hickman is an illustrator and educator in comics. She began creating comics in 2001 focusing on autobiography. She has taught comics workshops in secondary schools since 2014. During this time she earned an MA degree from University of the Arts, London where she began writing her graphic novel about her formative years in a mining village in the 1980s.

IT'S FINE, IF EVERYTHING YOU ARE MAKING IS CRAP

JUST KEEP MAKING IT

GATHER IT IN AN IMPRESSIVE PILE

SURVEY YOUR OWN CRAP KINGDOM

RUBYETC

RIGHT © Sally-Anne Hickman, 'Work Sucks', personal diary project, 2008.

Asia Alfasi
(1984–)

It is common for comics artists to recycle the same manga characters, but instead of referencing Japan and Japanese characters that already existed, Asia Alfasi decided to create new characters to communicate from her own culture. That had not been done before. It was this that set her work apart in the comics world.

Alfasi regards her work in comics as a meeting point for cross-cultural understanding between 'seemingly irreconcilable cultures'. She is currently working on her graphic novel *Ewa*, which traces the life of a Libyan family from the 1960s to the 1990s, a time of dramatic change.

Danny Noble
(1976–)

Danny Noble is a comic maker who regularly falls off stages with her band The Meow Meows. When not drawing her own misadventures, she tells made-up stories of naked Oliver Reed and naked Alan Bates. She's just illustrated *Tilly and the Time Machine*, the first children's book written by her comedy hero Adrian Edmondson.

RIGHT © Asia Alfasi, 'I'm as imprisoned as an eagle: flying high', date unknown.

BELOW © Danny Noble, 'Who I Am', personal diary project, 2016. 'I drew this as part of my compulsive diary keeping. I was walking home desperate for the loo and though this conversation was fictional, I realised it completely encapsulated who I am and how I cope with life.'

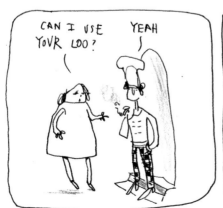
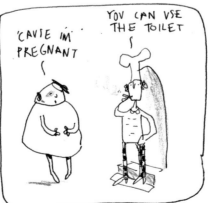
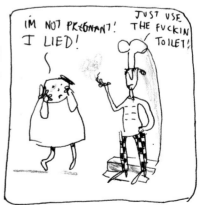

Simone Lia

Simone Lia is an artist and writer and creator of the weekly comic strip, 'Things That I've Learnt', in *The Observer*.

'The newspaper gives me freedom in the subject matter. It's semi-autobiographical and through it I like to explore themes of what it is to be human.'

She often communicates her ideas using anthropomorphism. *Fluffy* (Jonathan Cape, 2007) was initially self-published in four volumes.

Lia describes it as 'a story of unanswerable questions, love, despair, adventure and happiness'.

Her work has been published and exhibited internationally. She lives and works in London.

TOP © Simone Lia, *Fluffy*, page 21, Jonathan Cape, 2007. *Fluffy* is a comic tale of a baby rabbit that insists that a single man is its father, or 'daddy'.

MIDDLE © Simone Lia, 'Wanting a Happy Life', from 'Things That I've Learnt', *The Observer*, 2016.

BOTTOM © Simone Lia, detail from 'Parental Approval', from 'Things That I've Learnt', *The Observer*, 2016.

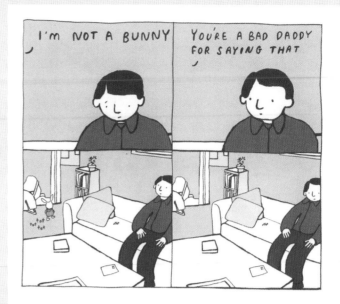

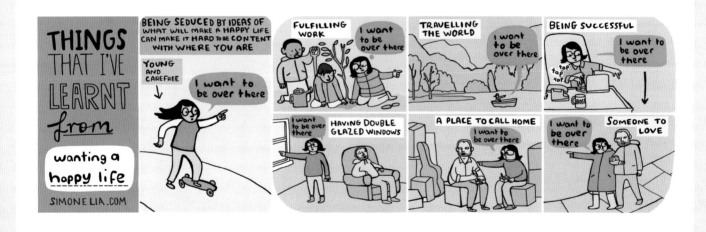

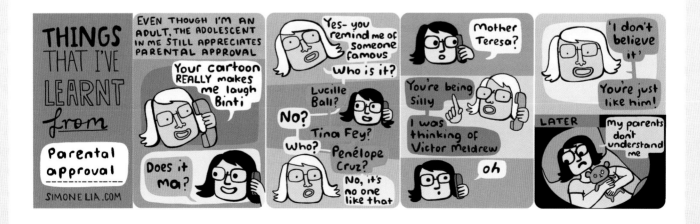

Gemma Correll
(1984–)

Gemma Correll is a cartoonist, writer and illustrator. Her books include *A Cat's Life* (2012), *A Pug's Guide to Etiquette* (Dog 'n' Bone, 2013) and *The Worrier's Guide to Life* (Andrews McMeel Publishing, 2015). She draws online cartoons 'Four Eyes' (GoComics.com) and 'The Nib' (Medium.com). Her work also appears on greetings cards and other merchandise. She went to art school in Norwich, UK and now lives in the US.

'Comics were always something that I did "on the side"– I didn't consider them to be "real" art, or something that I could pursue professionally, because the kinds of cartoons I saw in newspapers had a different sort of humour and seemed a lot more geared towards boys and politics.

'Imposter syndrome is a big obstacle for me when making comics and in putting myself – or my work –"out there". I think women do experience it more intensely, although it affects both sexes.

'I have been on panels where I have been interrupted, talked over and even belittled by male participants.'

REAL LIFE HORROR MOVIES

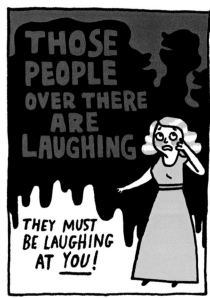
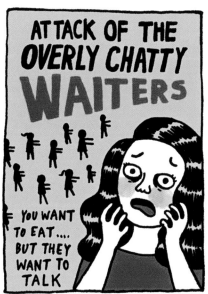

ABOVE © Gemma Correll, 'Real Life Horror Movies', from *The Worrier's Guide to Life*, Andrews McMeel Publishing, 2015.

Devi Menon
(1980–)

Devi Menon is a software professional by day and a bedtime story weaver by night, forced to concoct a tale from five random words that her niece and nephew come up with – tales of moons, cats, clocks, blues and much of muchness.

'"Alma Mater" is a personal work that stemmed from a germ of an idea I had about two long lost friends reuniting over a pickle jar. The story has evolved from that point to a tale of finding "home" each step of the way. I was born in Kerala, India and moved out to another city for higher education and then to other cities and overseas for work.

The home that I have created for myself today is thousands of miles away from where I started, and this book reflects a lot of it.'

LEFT © Devi Menon, 'Alma Mater', 2018.

BELOW © Rachael Smith, pages from graphic novel, personal project, 2017.

Rachael Smith
(1985–)

Rachael Smith is the creator of critically acclaimed graphic novels: *House Party* (Great Beast, 2014), *The Rabbit* (Avery Hill, 2015), *Artifical Flowers* (Avery Hill, 2016), *Wired Up Wrong* (self-published 2017).

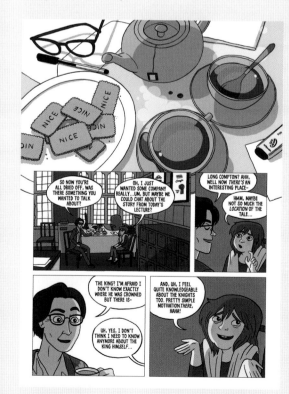

The everyday as political

Nicola Streeten

As well as the more immediately autobiographical works based on personal experience, the comics form has been applied to interrogating the wider everyday context. Whilst not political in the sense of addressing party politics, a body of works has emerged that engages with ideologies, from comics that directly reflect feminist politics to those that question and satirise subjects such as the role of the media. Comics are being used to address everyday assumptions around subjects including immigration, aging and disability.

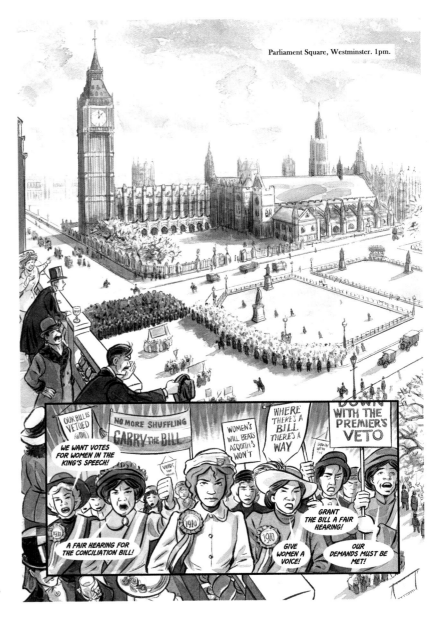

RIGHT © Kate Charlesworth, from Kate Charlesworth, Bryan Talbot and Mary Talbot, *Sally Heathcote: Suffragette*, page 79, Jonathan Cape, 2014.

Carol Swain

(1962–)

Born in London, Carol Swain was brought up in Wales. She studied painting at art school. In 1988 she began self-publishing her comic *Way Out Strips* (1988). Her graphic novels include *Invasion of the Mind Sappers* (Fantagraphics, 1996), *Foodboy* (Fantagraphics, 2004), *Crossing the Empty Quarter and other Stories* (Dark Horse, 2009), and *Gast* (Fantagraphics, 2014). She has also contributed numerous comics stories to anthologies worldwide. Many of Swain's stories are set in Wales, and are grounded in autobiography.

Mary Talbot

(1954–)

Mary Talbot is an academic who now writes graphic novels. *Dotter of her Father's Eyes* with Bryan Talbot (Jonathan Cape, 2012) won the 2012 Costa Biography Award. Her second novel, *Sally Heathcote: Suffragette* (Jonathan Cape), with Kate Charlesworth and Bryan Talbot, came out in 2014 and her third, *The Red Virgin and the Vision of Utopia* (Dark Horse Books), also with Bryan Talbot, in 2016. Her academic books deal with language, gender, media and power.

ABOVE © Carol Swain, *Gast*, page 133, Fantagraphics, 2014.

Una

(1965–)

Becoming Unbecoming (Myriad Editions, 2015) has been published in the UK, US/Canada, Spain, Brazil, the Netherlands and was featured on BBC Radio 4's Woman's Hour, *Newsweek*, *New York Times*, El Pais and Oprah.com.

The comic is an account of Una's experience of sexual abuse against the backdrop of the killings of women by Peter Sutcliffe in the 1970s 'Becoming Unbecoming was motivated by the need to discuss misogyny and sexual violence as an everyday aspect of too many lives.'

A graphic work *On Sanity: One Day In Two Lives* (2016) was published with support from Arts Council England, 'based on a zine I made in 2012 about caring for my mother through a psychosis and focusing on the day I waited for her to be taken to hospital under a section [of the Mental Health Act].'

Una is the first graphic novelist to be commissioned by New Writing North (2017–2019).

'I'm interested in the everyday detail of being a woman.'

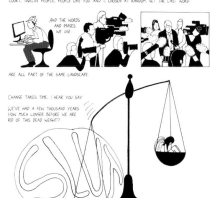

ABOVE © Una, *On Sanity: One Day In Two Lives*, self-published, 2016.

LEFT © Una, *Becoming Unbecoming,* page 69, Myriad Editions, 2016.

T.O. Walker
(1980–)

'I wanted to have a voice and comment on responses to sexual violence by the media, general public and services, including looking at victim blaming and racism.'

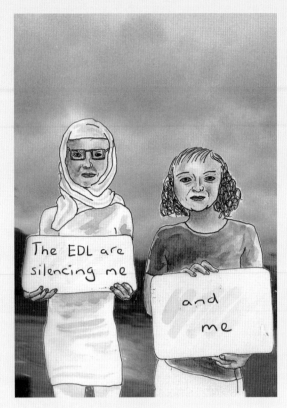

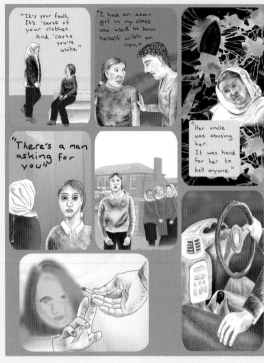

Maria Stoian
(1991–)

Maria Stoian is a Romanian-Canadian illustrator based in Scotland. Her first graphic novel, *Take It as a Compliment* (Singing Dragon, 2015), is a collection of real-life stories of sexual violence and harassment, domestic abuse and child abuse.

The anonymous stories in *Take It as a Compliment* were collected online, through emails and interviews and clearly show that assault of any type is not an honour bestowed on anyone. It is not a compliment.

Stoian makes comics and zines and has recently begun illustrating ceramics made by Natalie J. Wood.

ABOVE LEFT © T. O. Walker, *Not My Shame*, Singing Dragon, 2016.

ABOVE RIGHT © T. O. Walker, summary of *Not My Shame*, 2015.

LEFT © Maria Stoian, *Take It as a Compliment*, Singing Dragon, 2015.

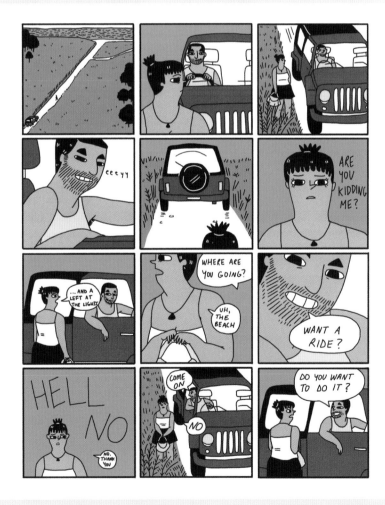

Kate Evans

(1972–)

Kate Evans is the author of the graphic novels *Threads from the Refugee Crisis* (Verso, 2017) and *Red Rosa: A Graphic Biography of Rosa Luxemburg* (Verso, 2015). She is also creator of *Funny Weather* (Myriad Editions, 2006) – a graphic guide to climate change, *Copse* (self-published, 2001) – about environmental protest, *The Food of Love* (Myriad Editions, 2008) – on breastfeeding and *Bump* (Myriad Editions, 2014) – about pregnancy and birth.

Threads is based on Evans' experience of visiting the Calais Jungle in 2015. She published the story as a comic to raise funds for the refugees, and then developed it further into a full-length book.

'I did a degree in English literature 25 years ago. It probably gave me confidence. I'm not scared of complex theoretical ideas, which was useful when researching *Red Rosa*.

'I think there is a confidence gap for female and BME cartoonists. When I met the (exclusively white male) members of the Political Cartoon Society, they described regularly sending daily cartoons to newspaper editors for months on end. When I have screwed up my courage to send a proposal, if/ when I didn't hear back, I took it quite personally and didn't bombard them with more.'

TOP © Kate Evans, 'Newbury', from *Copse*, originally a graphic reportage for the Environment section of *The Guardian*, 1996.

RIGHT © Kate Evans, *Threads*, page 8, Verso, 2017.

Myfanwy Tristram
(1968–)

Myfanwy Tristram draws inspiration from big issues, like politics, and subjects closer to home, such as parenthood.

'In 2016, the political climate – Brexit, Donald Trump, austerity, etcetera – inspired me to bring together a group of international comic artists for the Draw The Line project. The aim was to empower people who might otherwise have felt powerless,

by depicting positive political actions that anyone could take. These actions – over 130 of them in the end – were crowd-sourced amongst the group, by use of a shared Google document and discussion on Facebook.

'I then went through and matched artists to the actions which I thought would best suit their style of work and/or personal interests, judging by their previous comics. Most participants created a single image and then,

as there were a few left over, anyone who wanted to was invited to draw a second one.

'While many of the actions for Draw The Line were more directly "political" (such as arranging a march; contacting your MP; standing for election yourself) some of them, like mine, showed how you could work against the harm being done by our politicians in areas such as the environment, women's rights, or support for the disabled.'

BELOW © Creative Commons 4.0, Myfanwy Tristram, 'Go Cross Country'.

Karrie Fransman

(1981–)

Karrie Fransman's comics have been commissioned by *The Guardian*, *The Times*, the *New Statesman*, the BBC, the Arts Council, Southbank Centre and Manchester Art Gallery. Her graphic novels include *The House That Groaned* (Square Peg, 2012) and the award-winning *Death of the Artist* (Jonathan Cape, 2015).

Over, Under, Sideways, Down is the story of an Iranian teenage refugee fleeing conflict, and was created for The British Red Cross for Refugee Week in 2014. The comic book was based on interviews with asylum seekers.

ABOVE © Karrie Fransman, *Over, Under, Sideways, Down*, page 2, British Red Cross, 2014.

Hannah Berry

(1982–)

Hannah Berry's latest graphic novel is *Livestock* (Jonathan Cape, 2017), a troublingly prescient satire of celebrity obsession and the media in the twenty-first century. It follows the critically acclaimed *Adamtine* (Jonathan Cape, 2012) and *Britten & Brülightly* (Jonathan Cape, 2008) (Angoulême International Comics Festival Official Selection 2010). She drew a weekly cartoon strip for the *New Statesman* which ran between 2016 and 2017.

'In 2016, I wrote a story for *2000AD*'s special Free Comic Book Day issue, with illustrator Dani K from Greece. We were the first all-female team the publication had ever had. They've been running since 1977.'

RIGHT © Hannah Berry, *Livestock*, page 31, Jonathan Cape, 2017.

BELOW © Hannah Berry. 'Vox Pop: Old Lady Vengeance', *New Statesman*, 2016.

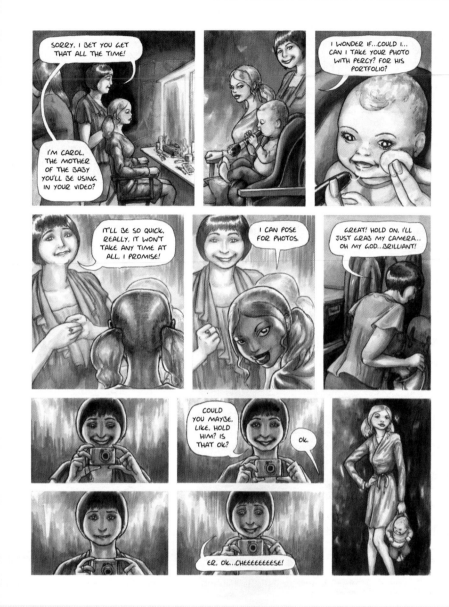

Lizz Lunney

(1983–)

Berlin-based comic illustrator Lizz Lunney began self-publishing zines in 2005, producing cartoons with light-hearted reflections on life and death.

'I do this self-initiated online project annually. This cartoon went viral and is the artwork which I have had most feedback from since I began working as a cartoonist over 10 years ago.

'I meant it as a response to the media, in particular newspapers that thrive on promoting horror and bad news to sell copies... I wanted to draw something to remind me to see things in a positive way. I think this is why this particular image hit a chord with others who also need that reminder.'

RIGHT © Lizz Lunney, 'The Good News', from Lunney's *Comic-A-Day August*, personal project (redrawn for print), 2017.

BELOW © Janette Parris, '82 Year Old Woman Refuses to Work Until She Drops Shocker', *Arch*, 2011.

Janette Parris

'The first *Arch* comic was originally commissioned at the end of a Cochme Fellowship residency at Byam Shaw School of Art. I have a multi-disciplinary art practice so had made comics and animations previously, but *Arch* was the first time I'd produced a comic using social engagement to create its content.

'I interviewed Girdlestone 3rd Age Group, a group of elderly residents who meet regularly in a community centre on the Girdlestone estate in North London.

'The first edition of *Arch* had a print run of 2,000 and was delivered free to all residents in Archway. It's now available online as well as in print.'

Ravi Thornton

(1973–)

Ravi Thornton is an award-winning cross-media scriptwriter. Her graphic novels *HOAX Psychosis Blues* (2014) and *The Tale of Brin & Bent and Minno Marylebone* (2012) are used in educational institutes around the world, supporting language in society and mental health studies. Her company Ziggy's Wish is dedicated to narrative innovation for socio-economic benefit.

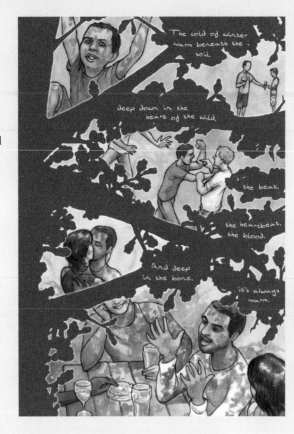

TOP LEFT © Ravi Thornton (writer), Hannah Berry (artist), from *HOAX Psychosis Blues*, page 84, Ziggy's Wish Limited, 2014.

TOP RIGHT © Ravi Thornton (writer), Rhiana Jade (artist), from 'Of Zeus and Leda' *HOAX Psychosis Blues*, page 47, Ziggy's Wish Limited, 2014.

RIGHT © Sophie Kamlish, 'Ready Steady Go'. Foundation work, Bath College of Art. This is part of a larger body of work exploring six different characters who are disabled and participate in sport.

Sophie Kamlish

(1996–)

'I am currently studying Illustration and Animation at Kingston university. I'm also a para-athlete so manage my time meticulously between art projects and training. I've been sprinting internationally since the age of 15 and have been lucky enough to travel the world to race, which has given me interesting things to draw.

'Initially I didn't want to be known as "the girl who always makes work about disability" but since starting university, I've come to realise that that's exactly what I want to make my work about.

'I've often found myself to be the only amputee in the room, which has given me a lot of experiences that my able-bodied peers have never had.

'I do my best to educate myself and others about disability within my work because it is often ignored or treated as a tragedy, which needs to change.'

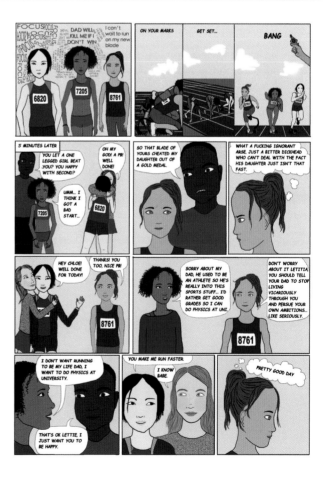

The ever-widening application of the comics form

The comic, above all, reigns as a form of entertainment and delight. And in this area new dimensions have been added to traditional literature such as Shakespeare and poetry. Comics have continued to be used in genres such as fantasy, folklore and horror, drawing on a variety of styles. And while graphic story-telling has always been used as an educational tool, its adoption by organisations, publishers and the media for use in teaching, informing and recording is rapidly increasing, for instance, Isobel Williams's drawings record and explain the workings of the Supreme Court. The Applied Comics Network, co-hosted by Lydia Wysocki, is an online network for anyone working with comics/graphic narrative and information. And while 'political' cartooning continues to be a male preserve, notable exceptions such as Bluelou, Lorna Miller, Henny Beaumont and Kate Evans have punctured the domain smartly.

Of course, the comics form continues to have its place in children's literature but in recent decades, children's comics have faced an uphill struggle to survive. *The Phoenix* has managed to buck this trend. The *DFC* comic was the initiative of David Fickling, who aimed to restore children's comics to 'where they should be'. It was a short-lived venture, but was reborn as *The Phoenix* in 2012 and in January 2017 celebrated its fifth birthday. A number of women comics artists have contributed, including the multi-award-winning illustrator and comics artist Sarah McIntyre.

BELOW © Sarah McIntyre, strip for 'Shark & Unicorn' series, Originally commissioned by *The Sunday Times* for *The Funday Times*, March 2014.

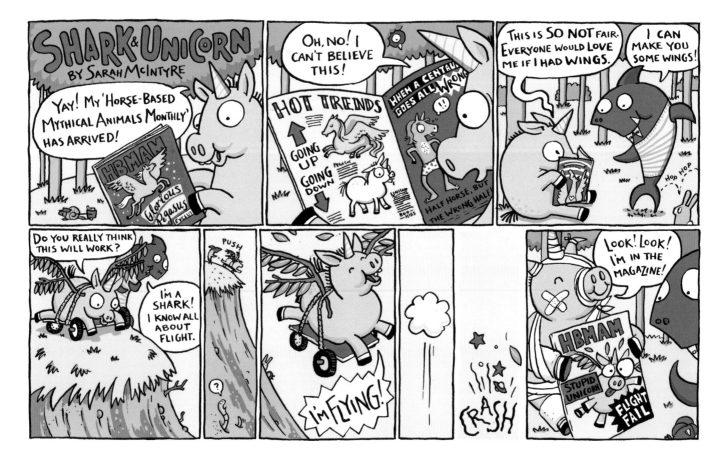

Isabel Greenberg

(1988–)

Isabel Greenberg is an illustrator and writer. Her first graphic novel *The Encyclopedia of Early Earth* (Jonathan Cape, 2013) won Best Book at the British Comic Awards. Her second graphic novel *The One Hundred Nights of Hero* (Jonathan Cape, 2016) was featured in the *New York Times* graphic books bestseller list.

Sarah McIntyre

Sarah McIntyre mostly draws and writes children's books. Her first published comic was *Vern and Lettuce* for The DFC in 2008.

'I love drawing fun worlds for kids to escape to, whatever the format. The energy and can-do, DIY-nature of the comics community taught me so much about the overall process of drawing and making stories. I love how in comics, I can create a mini comic, print it out, and sell it right away. And I love seeing kids running comics tables right next to grown-up professionals; I wish someone had told me I could do that when I was 10 years old.'

ABOVE © Isabel Greenberg, page from *The Encyclopedia of Early Earth*, Jonathan Cape, 2013. In *The Encyclopedia of Early Earth*, Greenberg creates an imagined ancient civilisation filled with all the wonder of myth and magic.

The tale follows the adventures of a lonely boy on his journey from the North to the South Pole, where he hopes to meet his true love.

Sarah Gordon
(1985–)

Sarah Gordon spent her childhood living in a 'very small' village, and most of her adult life living in London, which is 'very big'. Her work has been included in national and international publications, and was once described as 'disturbing' by *The Guardian* and 'Essential Indie Comics' by comics writer, Kieron Gillen.

'I have heard people openly questioning women's ability to 'do comics properly' before now, while individual male mediocrity in the medium is often given a free pass.'

Jessica Milton
(1991–)

Jess Milton is an illustrator, graphic facilitator and comic artist living in Glasgow, Scotland. She makes an ongoing webcomic called 'The Flying Ship', an adaptation of a Russian fairy tale with a queer cast at its centre.

'I wanted to make a comic that would be representative of me and the kinds of stories I love: fantasy and folklore, with a varied cast at the centre.'

LEFT © Jessica Milton, 'The Flying Ship', ongoing long form webcomic.

ABOVE © Sarah Gordon, 'Tehi Tegi'. Illustration for PM Buchan, *Heretics*, 2016. 'This print was commissioned as a pin-up for a small, indie comic. I drew my favourite Manx enchantress – a woman named Tehi Tegi who was infamous for bewitching and then drowning most of the male population of the Isle of Man.'

Tanya Meditzky
(1973–)

Tanya Meditzky is a member of Fancy Butcher Press, a loose collective of image-and-story-makers who share a love for the handmade, playful and absurd.

Sally Jane Thompson
(1984–)

Sally Jane Thompson is an artist and writer whose work includes comics for Oni, Dark Horse, Oxford University Press, *The Phoenix* and more, as well as live art, sketch reportage and illustration. Her work has a strong focus on expressive characters and an evocative sense of place.

'It's important to me that I draw a wide range of characters and not only one type of person. I believe very much in the power of people being able to see themselves in the books they read.'

Alison Sampson

An award-winning architect and illustrator, Sampson's comics work has been published worldwide, including (mainly) by Image Comics, as well as by Marvel, DC/Vertigo, the BBC and *The Guardian*. Her extensive portfolio of built work can be seen mostly in London.

In *Winnebago Graveyard* (2017), an American family on a road trip find themselves stranded in a small town with a dark secret. This horror-adventure story involves creepy fairgrounds, nefarious characters, seedy conspiracies and a town full of Satanists.

ABOVE © Alison Sampson and Steve Niles, cover art for *Winnebago Graveyard*, colours by Jordie Bellaire. Image Comics, July 2017.

Emma Vieceli
(1979–)

Emma Vieceli produced two graphic novels in SelfMadeHero's *Manga Shakespeare* series. *Hamlet*, (2007) was followed by *Much Ado About Nothing* (2009). Both books are based on abridged versions of Shakespeare's original text adapted by the writer Richard Appignanesi.

RIGHT © Emma Vieceli, *Much Ado About Nothing*, adapted by Richard Appignanesi, SelfMadeHero, 2009. 'The cemetery in this spread is actually my family's resting place in Italy. It sounds odd to say, but it's one of my favourite places. It's a massively peaceful place and I just knew it was where I wanted Claudio to pay his debt to the woman he so wronged.'

Chie Kutsuwada
(1967–)

'In 2016 I was asked to run a couple of manga workshops in Taiwan focusing on Shakespeare's sonnets and to adapt his classics into manga. I was then and still am a full-time self-employed comic creator/illustrator. I consider myself to be creating works for anybody, especially young female readers, who need some feel good escape pods from their rush of daily life.'

RIGHT © Chie Kutsuwada, *From William Shakespeare's Sonnets*: 'Sonnet 18'. Self-published, 2016.

Louise Crosby
(1962–)

Louise mainly produces comics illustrating poetry in an ongoing collaboration with Clare Shaw, Seeing Poetry: Poetry in words and comics. This included documenting an Art & Community project in Burnley in 2016. She also illustrates her own poems as artist books. She runs the Leeds branch of Laydeez do Comics.

RIGHT © Seeing Poetry (words: Clare Shaw; art: Louise Crosby), 'The Hebden Spotters Guide: Part 1'. *Hebden Bridge Annual*, The Egg Factory, 2016. A poetry comic about lesbian spotting in Hebden Bridge.

INKO
(1974–)

Raised and initially trained in Japan, Inko has lived and worked in the UK since completing a degree at Central Saint Martins, University of the Arts, London in 2003. Influenced by manga, she has turned down commercial work when she felt uncomfortable about the portrayal of women characters in the narratives.

'I cartoon all day, every day. [It's] so enjoyable and rewarding; I'll never stop.'

LEFT © Inko, 'Go! Go! Metrolines!', webcomic. This illustration for the webcomic 'Go! Go! Metrolines!' was influenced by the Japanese tradition of the personification of inanimate objects. Inko is a train spotter and thought it would be 'lovely to have a webcomic tell rich stories about unique London underground lines based on historical facts'.

Jessica Martin
(1962–)

Jessica Martin is an actress as well as a comic artist, and a number of her subjects have been from the world of stage and screen. *Vivacity* tells the story of Vivien Leigh, the British actress who became legendary for her portrayal of Scarlett O'Hara in Gone with the Wind.

An extract from *Elsie Harris Picture Palace* was shortlisted for the Myriad First Graphic Novel competition in 2014, and was published by Miwk Publishing in 2015.

'To find an art form in which I could be my own 'producer' was like a metaphorical philosopher's stone.

'I have benefitted from the support and encouragement of others in the comics industry. Attending Laydeez do Comics was very influential in creating a sense of excitement and camaraderie with other creators on the same path. It can be a very solitary process; those alliances are really important.'

RIGHT © Jessica Martin, *Vivacity*, self-published, 2014.

Karen Rubins

(1979–)

'In the small-press comics scene, around 2000 when I started out, seeing a woman making indie comics was (still) a novelty for a lot of people, it was very male-dominated. There were only three or four women creators in the whole room at a convention in those days. I'm glad that over the past 15 or so years, there have been far more women making their own comics.'

Jess Bradley

(1980–)

Jess is an illustrator and comics artist and writer currently living in the South West of England. She writes and draws 'Squid Bits' for *The Phoenix*, as well as self-publishing her own work. She is currently also working on a comic series called 'Tiny Overlord' about the many adventures and misadventures of being a parent.

LEFT © Karen Rubins, artwork for 'The Shivers – Crybaby', page 4. Script by Daniel Hartwell. *The Phoenix*, 26 October 2013. Karen Rubins and Dan Hartwell's series 'The Shivers' is a horror comic for the young. Some parents have criticised the stories for being too scary, some children have complained they aren't scary enough. This is part of a four-page story that appeared in *The Phoenix* comic.

RIGHT © Jess Bradley, 'Cecil P. Wombat: Expert on Everybody', *Moose Kid Comics*, 2013.

Laura Howell
(1980–)

Laura Howell is the first woman comic artist to draw a regular strip in *The Beano*, in its nearly 80 years of publication, and the first to draw one of the most famous characters in British comics, Dennis the Menace. Howell won the International Manga and Anime Festival (IMAF) Best Comic Award in 2006. She has contributed to *The DFC*, *Viz*, *MAD Magazine* and a number of small-press publications. She has also published her own comics.

Lucy Bergonzi

Lucy Bergonzi is an illustrator with a background in the voluntary and community sector, including several years supporting people with learning disabilities. She has illustrated several titles for Books Beyond Words, publisher of picture-led books for people with learning disabilities; including *A Day at the Beach*, *Going to Church* and *Belonging*.

Carol Adlam

Carol Adlam specializes in graphic novels, reportage, and book illustration (children's and older). She has illustrated books and short stories including *Ministry of Women* (for the National Army Museum, London), *Suzanne's Story* (University of York), *The New Wipers Times* (Nottingham Castle Museums and Galleries), *Amy in Love*, and *Thinking Room*.

Suzanne's Story is based on the testimony of French Holocaust survivor Suzanne Rappaport-Ripton. After carrying out interviews with the York and Harrogate branch of the Association of Jewish refugees and other Holocaust educational organisations, the York University Personalising History project felt that producing a short graphic novel would be a good way to make the experience of Holocaust survivors accessible to Key Stage III students.

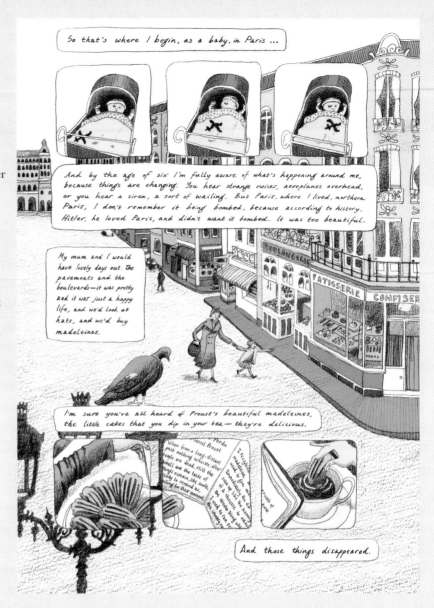

ABOVE © Carol Adlam, *Suzanne's Story*, University of York Personalising History project, 2014.

Jenny Drew

(1983–)

Jenny Drew is a therapeutic arts facilitator and cartoonist based near Bristol. The author of *Cartooning Teen Stories* from Jessica Kingsley Publishers – which explores using cartooning as a communication tool and medium of expression with those who are seldom-heard. Jenny is a resident live cartoonist of Bristol's Fringe performance scene.

LEFT 'Clown-o-therapist' Holly Stoppit , live cartooning, 2017.

Comics and social change

Sofia Niazi

Cartoons and comics can go a long way to steering the tide of public opinion and political change. Self-initiated work by cartoonists, comic book artists, graphic journalists, graphic novelists and illustrators have been at the forefront of pushing the medium to engage with social issues in order to change public perceptions of mainstream narratives.

Comics made by the activist artist/collective rarely come in the form of hard-bound published books, the material form symbolising something else. Responsive and urgent work is often delivered in the form of posters, short comics, pamphlets and zines – quick to produce and often rough around the edges; these comics are used to communicate important messages clearly and quickly. For me, these self-initiated works are the most exciting; they don't require a great deal of skill but rely more heavily on ideas, enthusiasm and collaboration. The DIY nature of zines and comics, and the associated social spaces they move through, allow people to come into contact with new information and different perspectives and can help foster solidarity amongst various groups and movements.

In 2013, Helena Wee, Hamja Ahsan and I started the annual DIY Cultures Festival, London. It was a result of our enthusiasm for self-publishing and also our disappointment in the lack of diversity at the zine fairs we had attended. We aimed to produce a fair which centered the voices of people of colour and featured comics, zines and publications exploring the intersections of art and activism. The one-day festival, which attracted over 2,000 people in 2017, has evolved over the past five years and currently consists of a zine fair, exhibitions, workshops, contemporary craft, panel discussions, video art and digital animation exploring DIY practice. A bustling zine fair with over 90 exhibitors from across the UK and beyond is at the heart of the festival. Comics about race, mental health, feminism, food justice, social housing, immigration, the War on Terror and overlooked histories – to name but a few – are visible at DIY Cultures and are often produced in tandem with grassroots movements implementing strategies to bring about social change. A genuine desire from comics and zine makers to learn from, support and collaborate with one another is something I've observed both as an exhibitor at various comics and zine fairs over

the years and as a founding organizer of the DIY Cultures Festival.

In the UK, *Shape and Situate: Posters of Inspirational European Women* (collated by Melanie Maddison, 2010–2015), is an example of a crowd-sourced illustrated publication. The A5 zine, which spanned seven issues, was 'born as a result of an appreciation of radical poster projects from the US, such as Celebrate People's History and Inspired Agitators'.[1] Each issue began life as an open call for artists to submit posters of radical, inspirational women such as organisers, activists, pioneers, educators, and role models – from a wide range of disciplines. I learnt about the project when Maddison approached me to submit a poster for the fourth issue of the zine. The project sought to share stories of various inspirational women 'as a way of connecting us with the past and the present through a cultural articulation of these women's lives'.

In 2013, after a brief stint in art school and taking inspiration from the many collaborative zines that came before it, I joined Rose Nordin and Sabba Khan to start our own zine project, *One of My Kind (OOMK)*. Exploring the faith, art and activism of women, the zine (currently edited by Sofia Niazi, Rose Nordin and Heiba Lamara) centres around the voices of creative women, particularly Muslim and women of colour. Each issue features essays, illustrations and comics from writers and artists submitting work in response to a different creative theme. The intention behind *OOMK*, as with many

TOP © Sofia Niazi, photograph of DIY Cultures Festival.

ABOVE © Sofia Niazi, *OOMK Zine Issue 1*, front cover, 2013.

OPPOSITE PAGE © Sofia Niazi, poster for DIY Cultures Festival 2017.

other collaborative zine projects, was to break away from the noise that mainstream media has to offer and to create a quieter and freer space for women to share their work and to learn more about each other.

Sincere and coordinated efforts to make intersectional comics and publications can act as a beacon of solidarity and demonstrate a commitment to communication across divides. Deploying voices and perspectives in such a medium ensures that it's not just the loudest or most popular voices that get heard in the push for social change there's room for quieter voices too.

Comics addressing social change are not the sole domain of the lone creative or the conscious collective. Comics are being used by governments, NGOs and philanthropic groups in their advocacy and outreach programmes to communicate stories and positions specific to an organisation's mission or a nation's foreign policy. Since 2012, the award-winning, UK-based non-profit PositiveNegatives has been producing literary comics, animations and podcasts about contemporary social and human rights issues, including conflict, racism, migration and asylum. They combine ethnographic research with illustration and photography; adapting

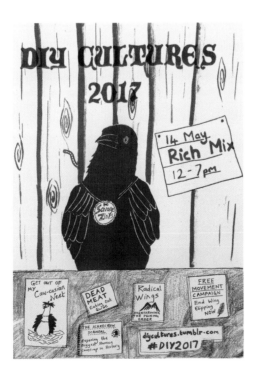

personal testimonies into art, advocacy and education materials.[2]

Projects which ultimately seek to disseminate an organization's values, however positive or progressive they may seem, through the medium of comics should not be seen as equivalent to self-initiated work of individual artists or an example of grassroots efforts to push for social change. When funding and salaries are tied up with outreach and advocacy programmes that seek to co-create or facilitate the creation of new comics, we ought to interrogate how the authenticity or agency of the work of a participant is affected. My intention is not necessarily to cast doubt on the integrity of the works created by NGOs, but to cast light onto the power relations at play when people are asked to divulge their stories or participate in comics projects tied up with broader project goals and motives. Many of the comics made as a result of such initiatives are informative, interesting and can lead to a diffusion of ideas that will help change attitudes, but if the conditions of creation are not made clear both to participants and those coming into contact with the material the interventions can be viewed as exploitative and the work produced as propaganda.

Whether the recent proliferation of self-initiated, DIY comics and zines made by untrained artists, as seen at DIY Cultures, is a response to our government's unwillingness to make formal arts education more accessible or whether those making art, comics and zines outside of formal institutions and finding audiences outside galleries is a rejection of the capitalist art world (as with *Strike!* and *Occupied Times*), current trends mark a change in the way we view viable routes to becoming artists. Using the medium of comics and zines to communicate in our own words and on our own terms has allowed us to change our own positions in society, from cultural consumers to cultural creators. Self-publishing and creating comics, whether online or offline, allows individuals and groups to articulate and communicate their beliefs, demands and ideas. It enables them to create a community and a base of common knowledge away from mainstream media. The work of artists and comics makers has been, and will continue to be, integral to supporting and building up movements which seek to mobilise the public to embrace and influence change.

Notes

Page 10

Mary Darly: Visual satire and caricature in eighteenth-century Britain *Sheila O'Connell*

(1) For example, more than 800 caricatures from the collection of Sarah Sophia Banks are now in the British Museum

Page 14

Women's suffrage in cartoons

Elizabeth Crawford

(1) See C. Rover, *The Punch Book of Women's Rights*, London: Hutchinson,1967.
(2) See entry in A.J.R. (ed), *The Suffrage Annual and Women's Who's Who*, London: Stanley Paul, 1913.
(3) A study of the Mary Lowndes Album, held in the Women's Library LSE, shows that on occasion Mary Lowndes altered the design or captioning of cartoons supplied by ASL members.
(4) See E. Mason-Hinchley, 'Why we want the Vote: the Woman Artist', *The Vote*, 12 August 1911.
(5) *Women's Franchise*, 27 June 1907.
(6) *Women's Franchise*, 30 January 1908.
(7) The image is likely to date from 1910 when the women chain-makers of Cradley Heath endured a ten-week strike, claiming a minimum wage that had been proposed by the Chain Trade Board but resisted by the manufacturers.
(8) Some archive material relating to both the ASL and the SA is held by the Women's Library @ LSE; other information has to be culled from the suffrage papers.
(9) For use of the term 'Coffee Smokes', see D.M. Coates, *George Coates: His Art and Life*, London: J.M. Dent, 1937. Emily Ford's studio invitations included the offer of 'Coffee and Cigarettes'.
(10) The cartoon, based on 'This is the House that Jack Built', sets out in nine frames the history of women's demand for the vote. Marie Brackenbury later self-published it as postcard and leaflet. Her imprisonment was punishment for taking part with other suffragettes in a 'raid' on the House of Commons, dashing out from a hired pantechnicon that had been driven up to the building and attempting to force an entrance. Ironically this was an incident that caught the eye of the cartoonist for at least one commercial publisher.

Page 51

The expansion of feminist book publishing

Nicola Streeten

(1) Contributors to *Women Draw 1984* included: Naomi Alexander, Annalou, Renee d'Arcy, Ros Asquith, Ann Barefoot, Sue Beasley, Carey Bennet, Laetitia Bermejo, Helen Chadwick, Kate Charlesworth, Helen Cherry, Sally Corless, Hilary Driver, Riana Duncan, Mary Ellis, Diane Fisher, Jacky Fleming, Wanda Gorzgowska, Sophie Grillet, Linda Harding, Jo Harvatt, Julie Hoehn, Caroline Holden, June Huckerby, Cath Jackson, Marie-Helene Jeeves. Mishelle Jones. Kathryn Lamb, Christine Landreth, Annie Lawson, Jan Lewis, Maggie Ling, Marian Lydbrooke Margaret Maidment, Angela Martin, Paloma Massip-Pozo, Lyn May, Alison McEwan, Jean Meyer, Carel Moiseiwitsch, Birdget Moore, Stefy Morris, Mu Morris-Jones, Tina Moskal, Belinda Murphy, Marlen Nolta, Geraldine Outhwaite, Hilary Paynter, Ivy Pedley, Suzanne Perkins, Anna Pohl, Sarah Pooley, Viv Quillin, Fiona Scott, Robin Shaw, Jackie Smith, Judy Stevens, Kate Taylor, Sian Thomas, Sandra Warne, Sarah Webb, Willow, Tamsin Wilton, Elizabeth Winkler, Paula Youens.

Page 56

A resurgence of the postcard

Cath Tate

(1) The names of these bookshops often reflected the main thrust of their interests such as Green Leaf books (Bristol), Grassroots (Manchester), Mushroom (Nottingham), Days of Hope (Newcastle, known locally as the Haze of Dope), Books for a Change (London, set up by CND and War on Want) and of course the women's bookshops Sisterwrite (1978–1993) and Silver Moon (1984–2001) in London, and Womanzone (1983–1986) in Edinburgh.

Page 77

FANNY and The Directory of Women Comic Strip Artists, Writers and Cartoonists

Carol Bennett

(1) Contributors to the *Seven Ages of Women* (Knockabout) included: Melinda Gebbie, Kate Charlesworth, Caroline Della Porta, Julie Hollings, Corinne Pearlman, Carol Swain and Jackie Smith.
(2) Contributors to *FANNY* no. 1 'Ceasefire: Readjust Your Sense of Reality' included: Suzy Varty, Julie Hollings, Carol Swain, Viv Quillin, Marianna Kolbuszewski, Clair Gammon, Jackie Smith, Trina Robbins, Lesley Ruda, Jo McLaren, Cath Jackson, Wendy Eastwood, Jacqui Adams and Juliet Gosling, Lee Kennedy, Chris Best, Jennifer Camper, Sharon Rudahl, Barbara Nolan, and Annie Lawson.
(3) Contributors to *FANNY* no. 2 'Voyeuse: Women View Sex' included: Corinne Pearlman, Maggie Ling, Julie Hollings, Christine Best, Frances Bennett, Carol Swain, Arja Kajermo, Annie Lawson, Jo McLaren, Jacqui Adams, Rachael Ball, Jackie Smith, Wendy Eastwood, Lee Kennedy, Viv Quillin, Sian Thomas and Fiametta Alley.
(4) Contributors to *FANNY* no. 3, 'Immaculate Deception: Dissenting Women' included: Jackie Smith, Carol Swain, Lee Kennedy, Carolyn Ridsdale, Suzy Varty with Hilary Robinson, Kate Charlesworth with Wren Sidhe, Josephine Campbell, Helen McCookerybook, Annie Lawson, Alexandra Ansdell, Corinne Pearlman, Lizzy Baker with Val.
(5) Contributors to *Dykes' Delight* No. 1 included: Kate Charlesworth, Karen Platt, Jennifer Camper, Grizelda Grizlingham, Angela Natalie, Lucy Byatt, Leanne Franson, Roberta Gregory.

Page 138

Comics and social change

Sofia Niazi

(1) http://remember-who-u-are.blogspot.co.uk/p/shape-situate-posters-of-inspirational.html [Accessed: 31 October 2017]
(2) http://positivenegatives.org [Accessed: 31 October 2017]

Acknowledgments

Biographies

We would like to thank all the cartoonists who generously contributed to this book, both in terms of allowing the use of images of their works and also in participating in discussions with us along the way. Thank you for contributing written pieces to Carol Bennett, Elizabeth Crawford, Simon Grennan, Anita O'Brien, Sheila O'Connell and Sofia Niazi. A big thank you is extended to everyone at Myriad Editions, for enabling this project to materialise as a book. In particular we thank our editor, the unflappable Corinne Pearlman. Thank you to the ever-tolerant and ever-professional designer Marcia Mihotich. Thank you, too, to Woodrow Phoenix, for advice. Thank you also for the patience and support of everyone at Cath Tate Cards. Thank you to Kate Charlesworth, Anita O'Brien, and Corinne Pearlman who were part of the original team in realising the concept of 'The Inking Woman'.

This book, and the exhibition upon which it was founded, would not have been possible without the generosity and vision of Cath Tate of Cath Tate Cards, or the hard work and imagination of Anita O'Brien, curator at The Cartoon Museum, who, together with her team Simon Russell, Steve Marchant, Alison Brown and volunteers at the Museum, started the ball rolling.

We know there are many more artists whose work we were unable to include, because of space and time constraints. There are also a small number of artists who chose not to be included because they did not agree with being part of a gender-defined list, or because they were unsure of the selection process. Nevertheless, this book has been created in good faith and the hope that our readers will join us in this celebration. If you are aware of any errors, do please let us know.

Carol Bennett was co-publisher of Knockabout and founder, with Cath Tate, of FANNY – an imprint set up by Knockabout in 1991 specifically with the aim of promoting female creators. The line began with *The Seven Ages of Woman* (1990), exploring the different stages in a woman's life, and was followed by the *FANNY* comic anthologies: 'Ceasefire' (1991), protesting against the Gulf War, 'Voyeuese' (1992), exploring female views of sex, and 'Immaculate Conception: Dissenting Women' (1992) on religion. *Women Out of Line* was published in 1997.

Elizabeth Crawford is the author of several books on the women's suffrage movement including *The Women's Suffrage Movement: a reference guide 1866–1928*, Routledge, 1999 and *Art and Suffrage: a biographical dictionary of suffrage artists*, Francis Boutle, 2018. She is also a dealer in books and ephemera, specialising in suffrage material.

Dr Simon Grennan is a scholar of visual narrative and a graphic novelist. He is author of *A Theory of Narrative Drawing* (Palgrave Macmillan, 2017) and *Dispossession*, a graphic adaptation of a novel by Anthony Trollope (Jonathan Cape and Les Impressions Nouvelles, 2015). He is co-author, with Roger Sabin and Julian Waite, of *Marie Duval: Maverick Victorian Cartoonist* (Manchester University Press, 2019), *Marie Duval* (Myriad Editions, 2018) and The Marie Duval Archive (www.marieduval.org). Since 1990, he has been half of international artists team Grennan & Sperandio, producer of over 40 comics and books.

Sofia Niazi is an artist, illustrator and educator based in London. In 2013 she set up *OOMK* Zine (*One Of My Kind*), a biannual publication about women, art and activism, with Rose Nordin and Sabba Khan. She co-founded DIY Cultures Fair (2013–2017), a day festival exploring intersections of art, publishing and grassroots activisim.

Anita O' Brien has been curator at the Cartoon Museum, London, since 2003. She has curated exhibitions and co-authored catalogues on a range of subjects including the work of Ralph Steadman, Ronald Searle, Pont, Steve Bell, Martin Honeysett as well as on Margaret Thatcher and 'The Inking Woman' exhibition.

Sheila O'Connell was, for more than 30 years, a curator at the British Museum where her responsibility included the collection of over 20,000 satirical prints, mostly by men. She is the author of *The Popular Print in England* (British Museum Press, 1999), *London 1753* (British Museum Press, 2003), and (with Tim Clayton) *Bonaparte and the British* (British Museum Press, 2015).

Dr Nicola Streeten is an anthropologist-turned-illustrator and author of the award-winning graphic memoir, *Billy, Me & You* (Myriad Editions, 2011). She co-founded the international forum Laydeez do Comics in 2009. Her PhD was 'A Cultural History of Feminist Cartoons and Comics in Britain from 1970–2010' with a focus on the role of humour. She has been lecturing at the London College of Communication, University of the Arts, London, Kingston University and the University of Sussex.

Cath Tate set up Cath Tate Cards in the early 1980s, initially to produce political (anti-Thatcher) and feminist postcards. During the 1980s and 90s she published cards showing the work of many of the feminist cartoonists active at the time and conceived the idea of an exhibition and a book showing the work of women cartoonists. In the early 1990s she collaborated with Carol Bennett producing the *FANNY* and 'Dykes Delight' comics which showed the work of women comic artists. In 2017 she helped to curate 'The Inking Woman' exhibition at the Cartoon Museum in London with Kate Charlesworth, Anita O'Brien and Corinne Pearlman.

Index of names

Graphic books from Myriad
New ways of seeing

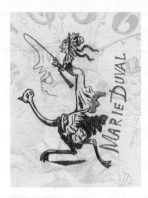

Marie Duval
Simon Grennan, Roger Sabin, Julian Waite

Marie Duval (1847–1890) was a ground-breaking cartoonist whose work, depicting an urban, often working class milieu, has been largely forgotten. Both a stage actress as well as an artist, Marie Duval confounds one of our most commonplace ideas of the Victorian era – that women were not supposed to create or to even participate in public life and certainly not meant to be either comic or professional. This glorious celebration of her times and art brings her centre stage after almost 130 years of obscurity.

ISBN: 978-0-9955900-8-3
£19.99 | 210mm x 270mm | 144 pages | Hardback

Myriad's list of graphic books presents a distinctive and diverse selection of unconventional viewpoints, controversial opinions, new voices, and great art. Comics, sequential art, narrative illustration, graphic novels – call them what you will – we publish some of today's most exciting cartoonists, with a topical, contemporary focus. And our First Graphic Novel Competition is committed to providing publishing opportunities for debut authors.

'A formidable reputation for bringing us some of the most thought-provoking and atypical graphic novels on the shelves'
Forbidden Planet

www.myriadeditions.com

CARTOON MUSEUM

www.cartoonmuseum.org
British cartoon & comic art
from the 18th century to the present day

Cath Tate Cards

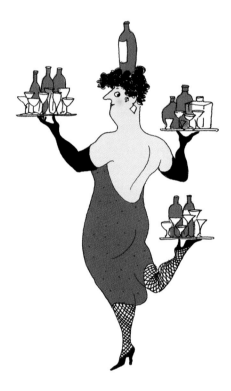

Cath Tate Cards has been publishing the work of funny women on cards, T-shirts, mugs, magnets and other ephemera since the early 1980s. The full current range is available from

www.cathtatecards.com